THE SECOND WC
IN PHOT

A

1945

THE SECOND WORLD WAR AT SEA
IN PHOTOGRAPHS

1945

PHIL CARRADICE

AMBERLEY

First published 2016

Amberley Publishing
The Hill, Stroud
Gloucestershire, GL5 4EP

www.amberley-books.com

British Library Cataloguing in Publication Data.
A catalogue record for this book is available from the British Library.

ISBN 978 1 4456 2254 5 (print)
ISBN 978 1 4456 2277 4 (ebook)

Typeset in 10pt on 12pt Sabon.
Typesetting and Origination by Amberley Publishing.
Printed in the UK.

Contents

Introduction 7

January 11

February 17

March 25

April 33

The End of an Era 43

May 47

June 57

July 69

Getting Back to Normal 77

August 91

The End of It All 103

September 109

Post-War 117

Introduction

When Allied troops landed on the Normandy beaches in June 1944, public expectation was high – the worst was over, the Atlantic Wall had been breached and the war would surely be finished by Christmas. At least that was what most people thought.

Yet, as 1945 dawned, the men of the German armed forces were still fighting a dogged and determined rear-guard action. The ultimate result might be inevitable but still the Germans fought, particularly on land, where the recent Battle of the Bulge had caught the Americans totally by surprise. At sea, their resistance was no less fierce.

In the face of relentless Russian pressure, German forces were withdrawn from East Prussia at the end of January. The last of the great capital ships of Hitler's navy, the *Prinz Eugen* and the *Admiral Hipper*, were both involved in the evacuation, escorting troop ships to the relative safety of the West.

Russian submarines now had virtual control of the Baltic, the sinking of the transport *General von Steuben* on 10 February proving the point. There were 6,000 people on board the stricken vessel, but only 300 survived the torpedoing. It was a disaster comparable to the sinking of the *Titanic* or the *Lusitania* but, as one of the final acts of the Russian campaign where millions – civilians and soldiers alike – had lost their lives, the event passed off with barely a comment.

Many of those who drowned were refugees rather than fleeing troops but such niceties mattered little in the last bloody and brutal stages of the war. Germany was still fighting desperately for survival and, as far as the Russians were concerned, refugees or no refugees, the *General von Steuben* was a legitimate target.

At the Yalta Conference earlier in the month, the Big Three had come together to discuss the conduct of the last phase of the war. President Roosevelt was clearly ill, but the American desire to procure Russian aid in the defeat of Japan led to significant concessions over things like the frontier of Poland. It was at this conference that Western Powers really began to appreciate the ambitions of Stalin and his regime. Even at this stage it was clear that there would be significant post-war tensions in Europe.

In the Pacific, the American drive towards the Japanese homeland continued, with US Marines landing on Iwo Jima on 19 February. Iwo Jima was strategically important to both sides, as its capture meant that American fighters could be deployed from landing fields on the island to escort long-range bombers operating against mainland Japan. By the same token, the Japanese needed to prevent the landing strips falling into American hands, and were therefore prepared to defend the island to the last man.

Fierce fighting took place on Iwo Jima for many weeks, most of it centred around two of the island's vitally important airfields. By the second week of March, all three of these island airfields were in American hands and the few remaining Japanese defenders had been pushed back to a small enclave on the northern coast. The campaign ended on 26 March, and American aircraft began to fly regular and sustained missions against Japan from Iwo Jima.

Japanese kamikaze attacks continued. The landings on Iwo Jima had been severely hampered by the suicide raids, with the aircraft carrier *Bismark Sea*, which had been supporting the landings, sinking after being hit by two kamikaze raiders on 21 February. With 318 men dead and many more injured, it was small consolation that this was the last US carrier loss of the war.

The carrier *Bunker Hill* was also severely damaged during the Iwo Jima landings. Casualties of over 600 (346 dead) made this the largest loss of life on any US carrier during the war. Several other US ships were damaged at the same time. On 30 March, the cruiser USS *Indianapolis* was hit by a kamikaze raider and put out of action for a brief period.

Despite further kamikaze attacks, the American landings on Okinawa began on 1 April. It was the largest naval operation in the Pacific Campaign, with over 1,000 landing craft and other transports taking the Marines ashore. Kamikaze attacks – and more conventional assaults by Japanese aircraft – caused damage to the supporting fleet, with both the USS *West Virginia* and the British carrier *Indomitable* being damaged during the landings.

On 6 April the battleship *Yamato*, thought at the time to be the most powerful warship in the world, left harbour in an attempt to wipe out the American fleet off Okinawa. It was another suicide mission, as the ship carried only enough fuel for the outward trip – she was never intended to return. Spotted by US reconnaissance aircraft, the *Yamato* was attacked by 350 Allied bombers on 7 April.

Hit by bombs and torpedoes, the *Yamato* sank quickly; only 269 men out of a crew of almost 3,000 survived. If anything underlined the demise of the giant surface warship in the face of aerial power, it was the sinking of the *Yamato*.

President Roosevelt, who had been ill and clearly fading for some time, finally died after suffering a fatal stroke on 12 April. He had been a vital friend to Britain during a period when America had maintained her independence and neutrality, and, after 1941, had thrown himself wholeheartedly into the defeat of Japan and Germany. He was succeeded by his vice president, Harry S. Truman.

Things were also beginning to change in Germany. Hitler's longstanding deputy, Herman Goering, was in disgrace and under arrest after suggesting peace talks with the Americans. On 29 April, Hitler appointed Admiral Karl Donitz as his

successor. It was an empty honour and one that Donitz neither wanted nor enjoyed but, in the best traditions of the German Navy, he would do his duty.

Hitler and his new wife Eva Braun killed themselves in the bunker in Berlin on 30 April.

Despite German forces surrendering to General Montgomery on Lunenburg Heath on 4 May, the U-boat war was not quite over. The *U-2336* achieved the last U-boat success of the war on 7 May and, with many German submarines still loose in the North Atlantic, the escort vessels could not afford to drop their guard, even for a moment.

VE Day was celebrated on 8 May and, with that, the war in Europe was formally ended. In the Pacific, however, the conflict continued to rage. Even so, things were reaching a conclusion and, when the Japanese cruiser *Haguro* was sunk by five British destroyers in the Malacca Straits on 15 May, it was the last action of the war between large surface warships.

On 28 June, General MacArthur broadcast the news that the Philippines Campaign was at an end, but President Truman knew that Japan still had to be invaded and conquered. Whenever that took place – and Truman approved the invasion plans on 29 June – it was going to be costly, both in equipment and in human lives.

The British election – the 'Khaki Election', as it was known – was held that summer, with Winston Churchill firmly believing that the British public, those in the forces and in 'civvie street', would remember what he had done for the war effort and return him to government. He, like most of those in public office, was astounded that, when the votes were cast, they showed a landslide victory for Labour. Clement Attlee duly succeeded Churchill on 26 July.

Churchill was not happy with his successor. 'A modest little man – with much to be modest about', he quipped in one of his more acerbic humorous asides.

On the same day that Attlee took office, the minesweeper HMS *Vestal* was hit and damaged by a kamikaze plane. She was later finished off by gunfire from an accompanying destroyer, Britain's last warship casualty of the war.

The decision to use an atomic bomb on a Japanese city was not one that Truman took lightly. He consulted with his advisors and sat pondering for many hours. He knew what a decisive weapon he now had at his disposal. At the end of the day, the decision was his. However, he came to the decision – and it can only have been in an attempt to save American lives that would have been placed at risk if the Japanese homeland had been invaded – the first atomic bomb in history was dropped on Hiroshima on 6 August. The effect of the bomb was devastating, with buildings, trees and people being wiped off the face of the earth.

When a Japanese surrender was not forthcoming, a second atom bomb was unleashed on Nagasaki on 9 August. Over 120,000 people were killed in the two attacks and, when Truman announced that unless Japan surrendered immediately more atomic bombs would be dropped, the result was, in the west at least, a growing belief that the end was close.

As far as the Japanese were concerned, it was not a totally clear-cut decision. The 'war party' in the Japanese Supreme Council wanted to fight on, and there were long and intense debates. However, eventually common sense prevailed.

The Japanese agreed to surrender, provided the Emperor could remain as a figurehead. This was agreed. VJ Day was announced on 15 August and, a few weeks later, on 2 September General MacArthur formally accepted the Japanese surrender on board USS *Missouri*. The Second World War had come to an end, six years and one day after it had begun.

January

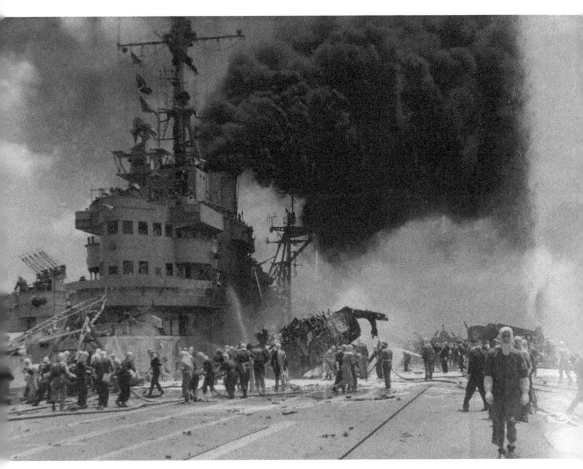

Kamikaze raids took an increasingly deadly toll on Allied shipping as the Japanese became more and more desperate.

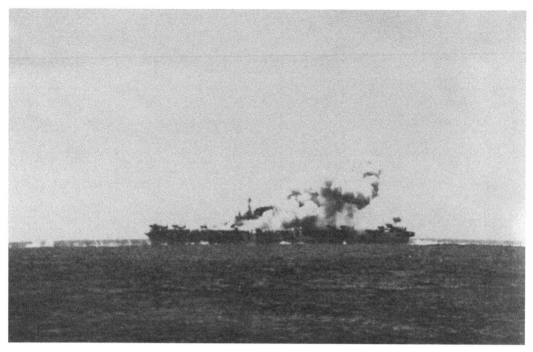

An aircraft carrier on fire after being attacked by Kamikaze raiders. Even if a ship was not sunk, the damage inflicted invariably put them out of action for many weeks or even months.

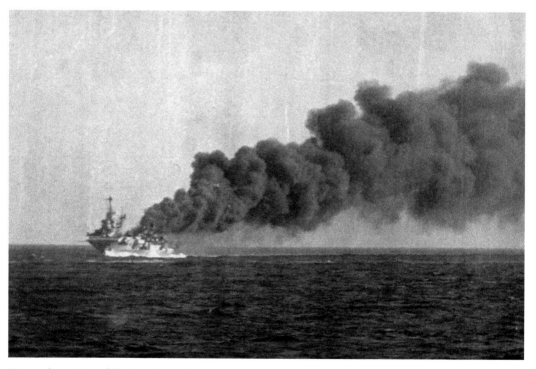

Yet another victim of the Kamikaze pilots.

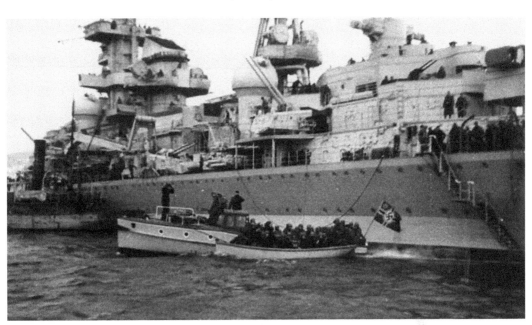

On 25 January, faced by overwhelming Russian forces, the German army evacuated East Prussia. The *Admiral Hipper* was one of several ships involved in transporting troops and refugees to safety.

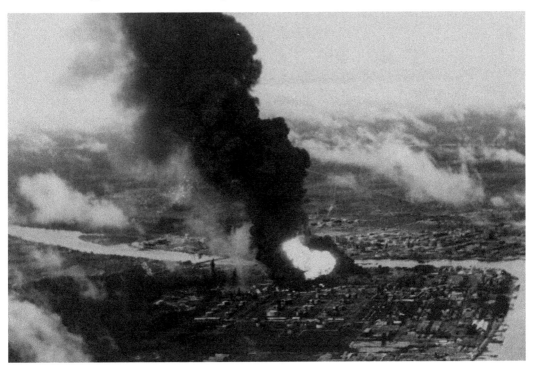

Operation Meridian was a series of British air attacks against Japanese-held oil refineries on the island of Sumatra. The raids took place on 24 and 29 January 1945, and were carried out by units of Task Force 63. The task force was on its way to Australia, but was diverted to carry out the attacks.

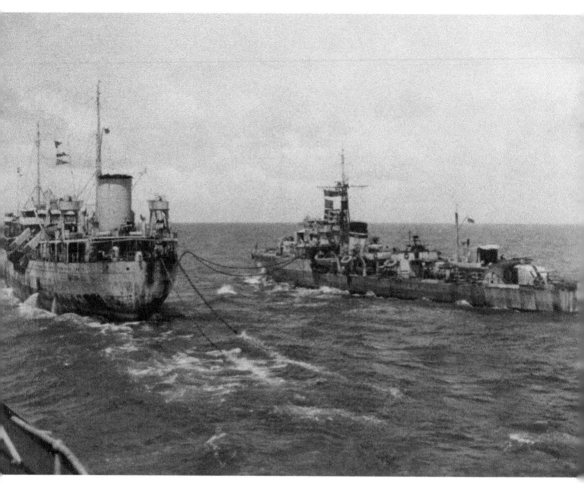

In order to press home the attacks, the ships of Task Force 63 had to be refuelled at sea – always a tricky operation. This shows an RFA tanker passing across fuel lines to a waiting destroyer.

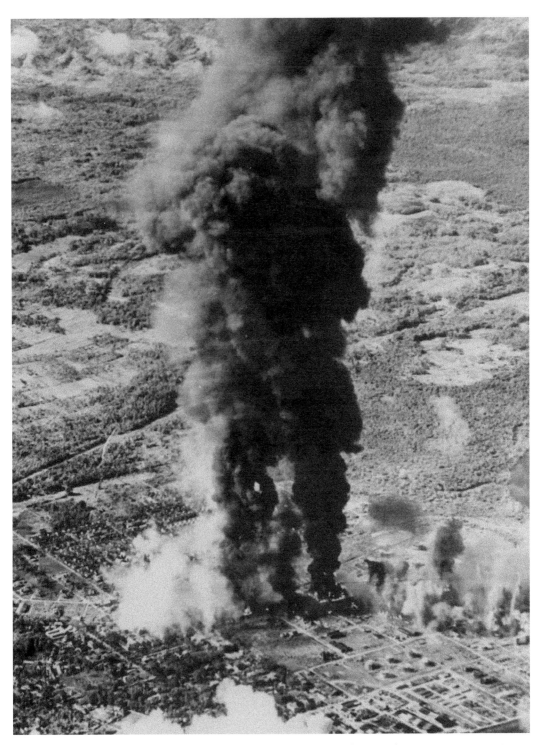

The raids were hugely successful, with the Japanese oil output dropping by over 70 per cent – just at the time when they needed it most.

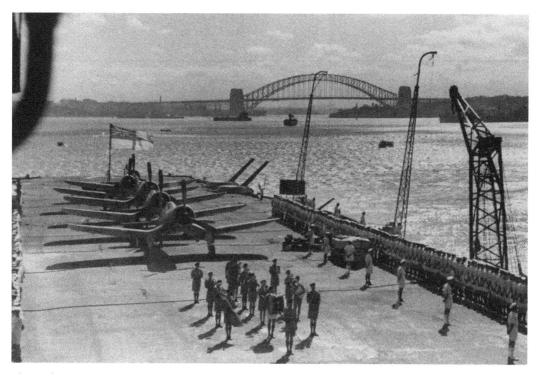

The raid over, Task Force 63 continued its journey to the Far East. This shows HMS *Victorious* in Sydney Harbour.

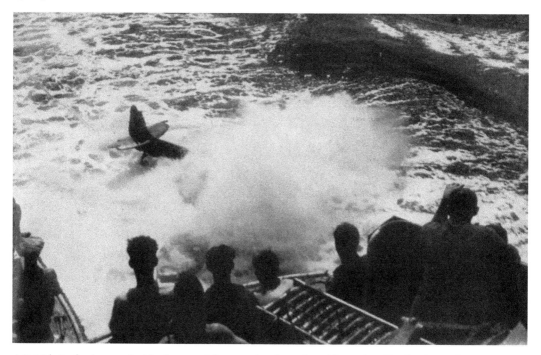

A British Seafire has crashed in the sea while returning from the raids on the oil refineries on Sumatra.

February

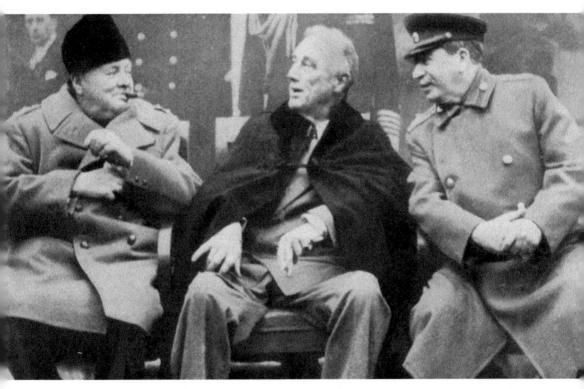

The Big Three – Churchill, Roosevelt and Stalin discuss the shape of the post-war world at the Yalta Conference.

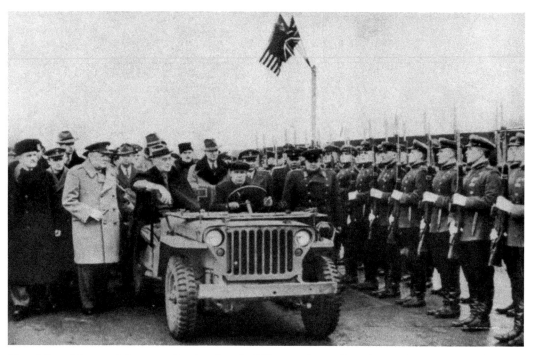

Churchill and Roosevelt inspect a Russian Guard of Honour during the Yalta Conference. Roosevelt, already ill and slipping slowly towards death, sits in the back of a jeep.

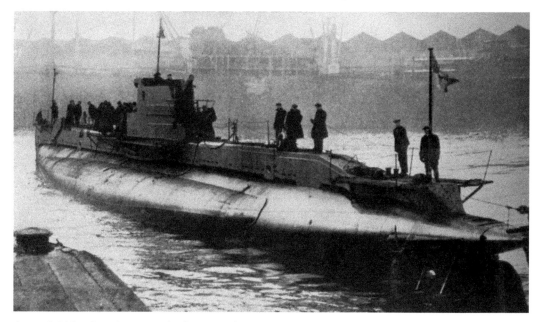

A new British submarine enters the fitting-out basin.

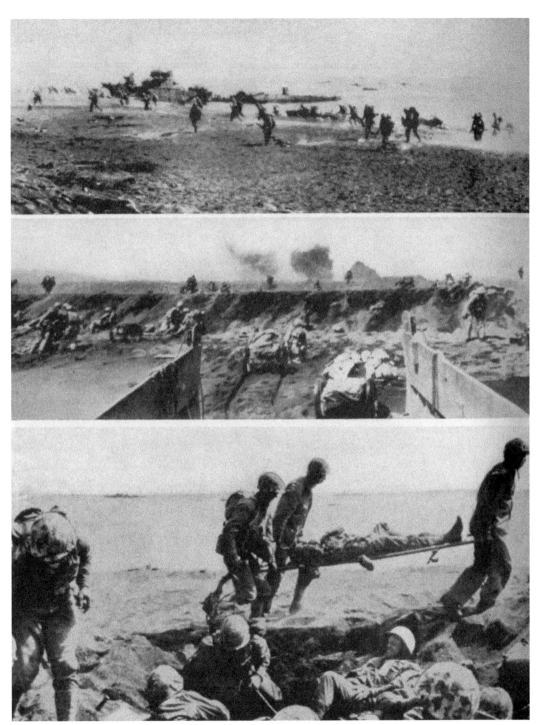

US Marines go ashore on Iwo Jima, 19 February 1945. The island is strategically important, as it will provide US forces with air strips for fighters used to protect the bombers now attacking mainland Japan.

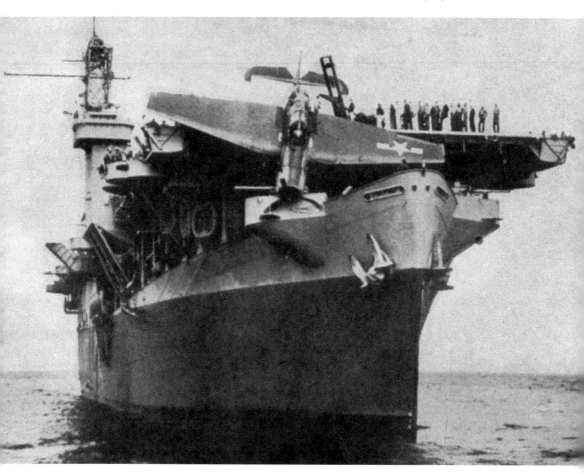

A Grumman Avenger that over-ran the flight deck of its carrier. The wreck hangs precariously over the bow of the carrier.

A sailor signals other ships, using a 20-inch signalling lamp – the quickest and most effective way of contacting other vessels without fear of interception by the enemy.

Clearing the guns of HMS *Queen Elizabeth*.

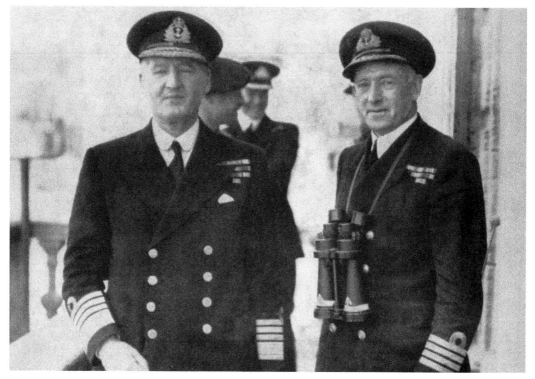

Admiral Sir Bruce Fraser (left), commander of the British fleet in the Pacific, with Captain Hickling.

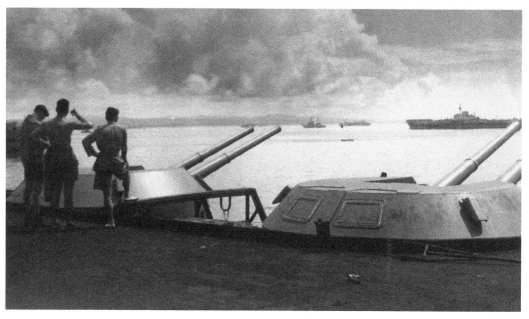

Always watchful – sailors on the deck of a British carrier in the Pacific. As spring approached, Japanese Kamikaze attacks intensified and the need to destroy the Kamikaze planes before they came too close meant that there was little time to relax.

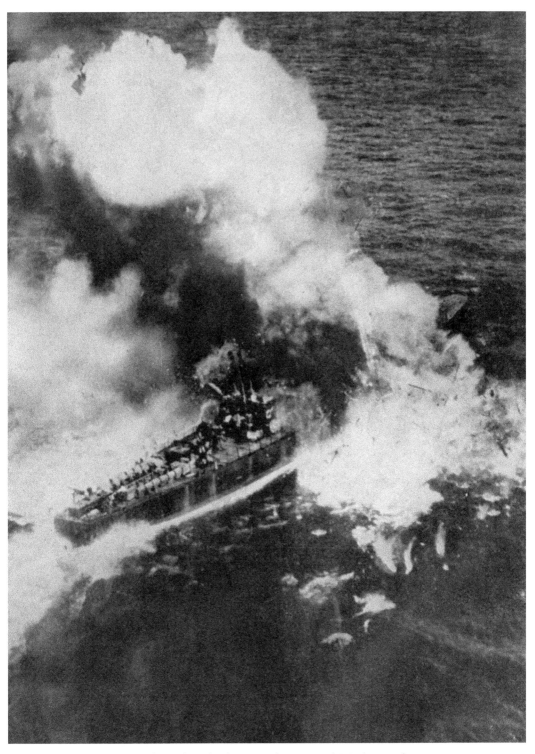

A Japanese destroyer takes a direct hit from attacking US and British aircraft.

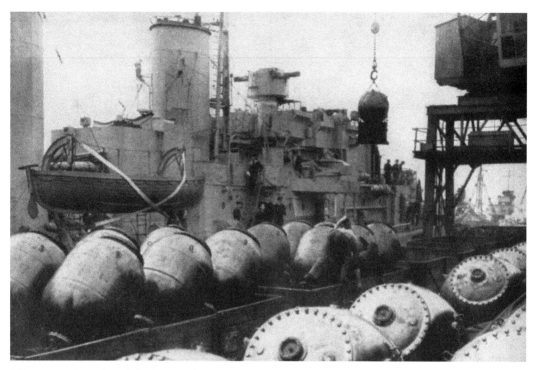

Mines sit ready on board the fast minelayer HMS *Manxman*.

March

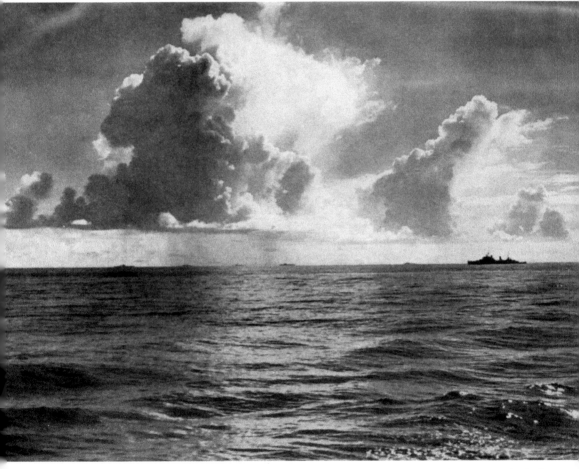

Ships of the British Eastern Fleet, the photograph taken from the deck of the battleship *Queen Elizabeth*.

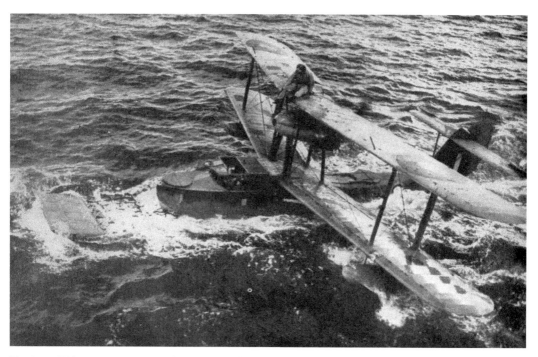

Towing a Walrus reconnaissance plane, prior to hoisting it out of the water.

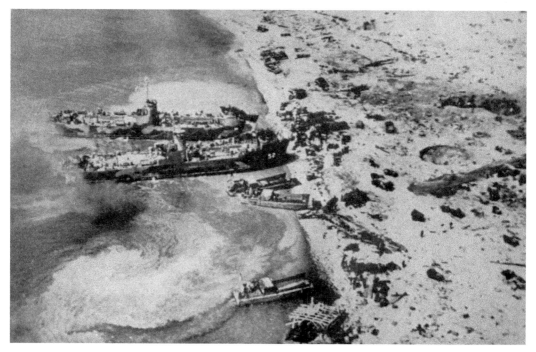

US marines come ashore from their LCIs during the landings on Corregidor, March 1945 – yet another successful action in the 'island-hopping' approach, which took US forces closer and closer to the main Japanese islands.

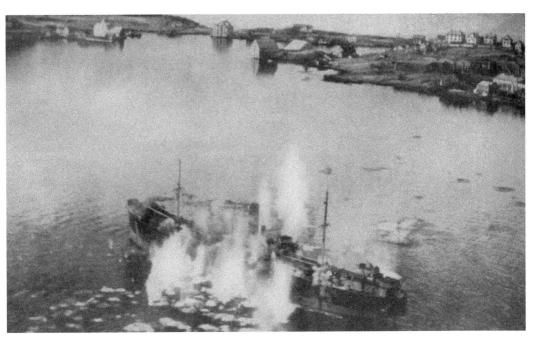

The war in the west continued to be waged with ferocity from both sides. Here a flight of Mosquito fighter bombers attack a German merchant ship in Aalesund Harbour, Norway.

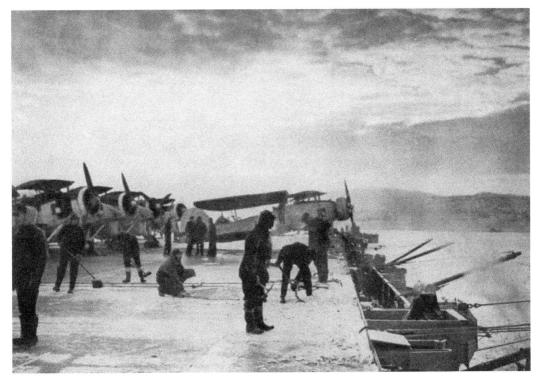

Clearing ice from the deck of the escort carrier *Campania*.

Mines continued to be laid until the end of the war – after all, no one knew how long hostilities would continue. This shows mines on the stern of a minelayer, ready to be dropped into the sea.

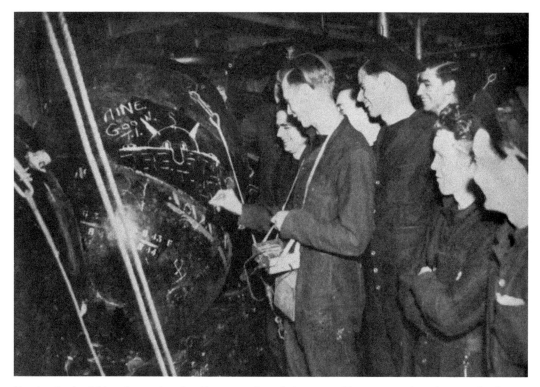

Despite the hardships they endured, sailors never lost their sense of humour, as this photograph of messages being chalked on the side of mines clearly shows.

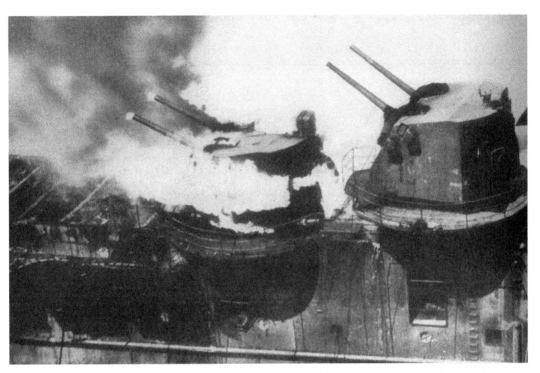

The US carrier *Franklin*, hit by armour-piercing bombs off the Japanese coast, 19 March 1945.

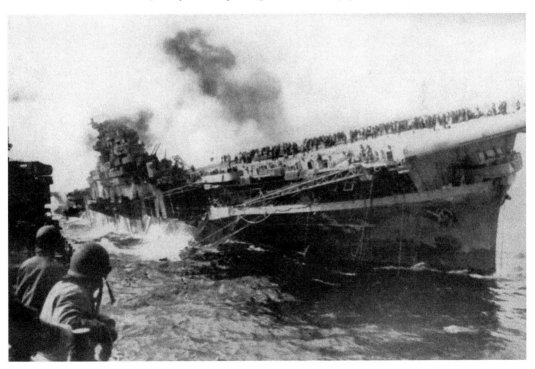

With nearly 1,000 casualties, the *Franklin* managed to limp home to her base in New York for repairs.

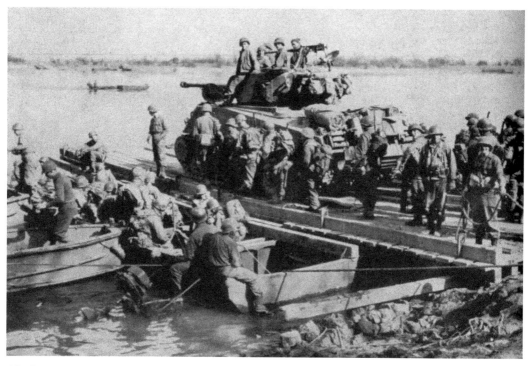

Allied troops crossing the River Rhine on assault boats, 22 March 1945.

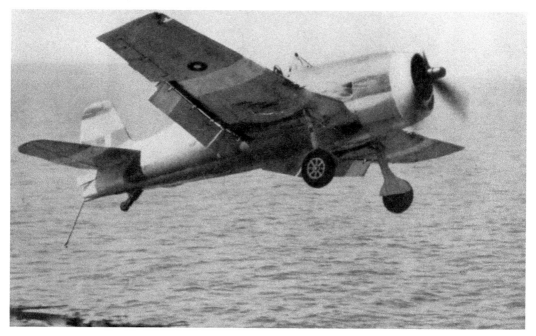

Landing on a pitching, rolling flight deck was never easy. This action photograph shows a Hellcat fighter attempting to land on the deck of an escort carrier. However, the pilot has misjudged his approach and will have to make a second attempt to get down.

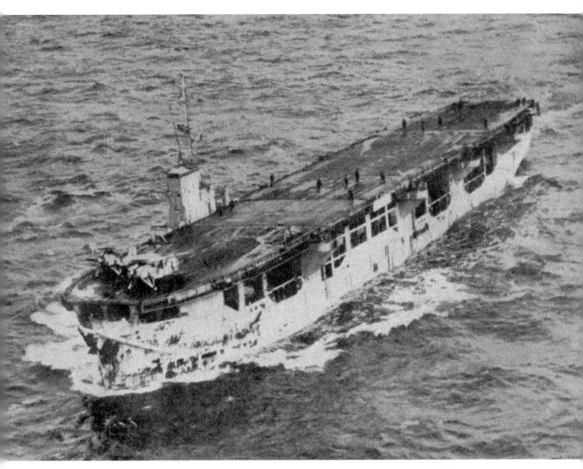

A merchant aircraft carrier, one of many such merchant ships fitted with a flight deck. Carrying cargo while operating as an aircraft carrier, these vessels played an unglamorous but vital part in the war.

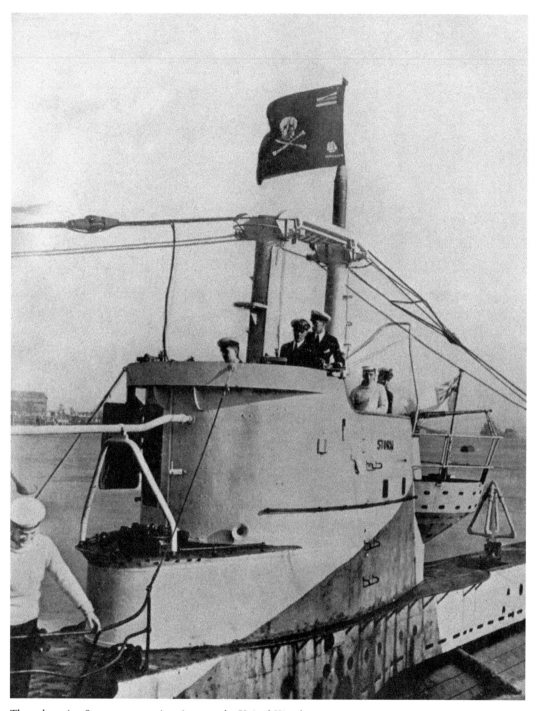

The submarine *Storm* returns, victorious, to the United Kingdom.

April

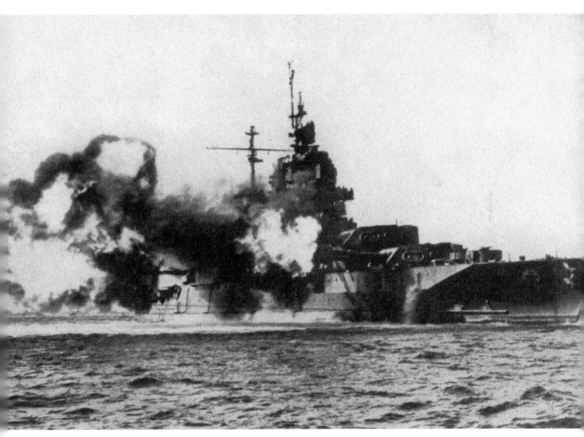

The US invasion of Okinawa began on 1 April 1945. With 500,000 Marines and over 1,000 transports involved in the invasion, it was the largest naval operation of the whole war in the Pacific. Prior to the invasion, Allied warships poured thousands of shells onto the Japanese positions. The Japanese responded with kamikaze attacks.

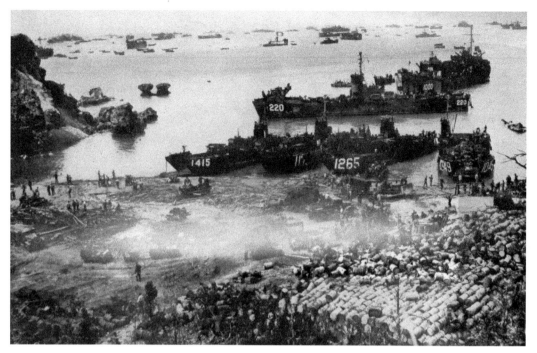

US landing craft at Okinawa. The Japanese defence of the island – less than 400 miles from Japan itself – was fanatical and led to hundreds of casualties on both sides.

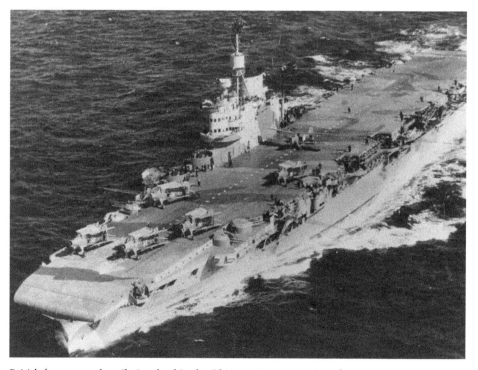

British forces were heavily involved in the Okinawa invasion – aircraft carriers in particular.

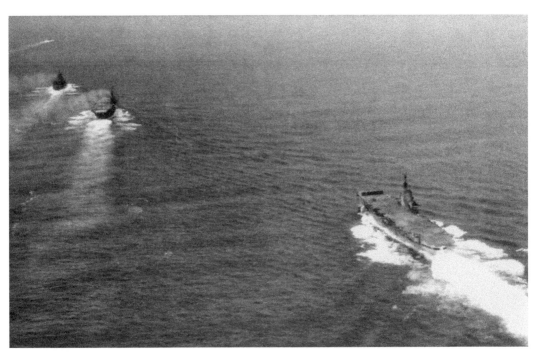

The British task force, operating off Okinawa.

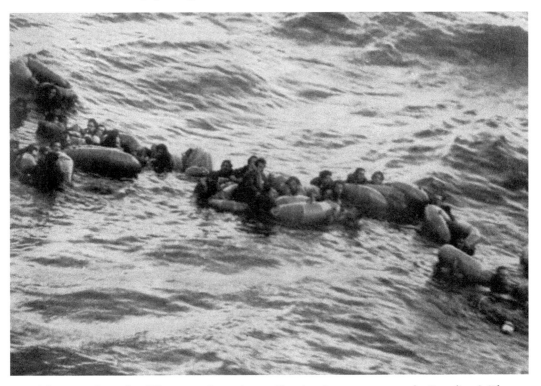

The crew of a sunken U-boat are taken prisoner. The victorious corvette was the Canadian *St Thomas*.

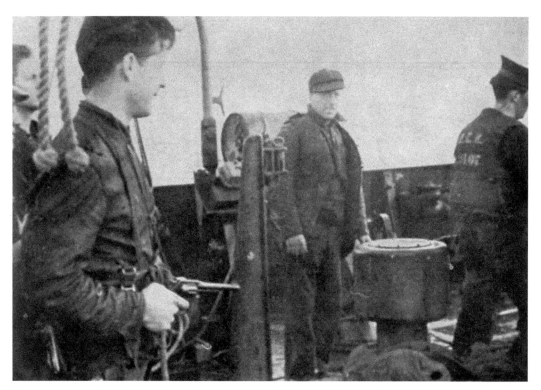

A crewman, armed with a pistol, watches as German U-boat prisoners are led below.

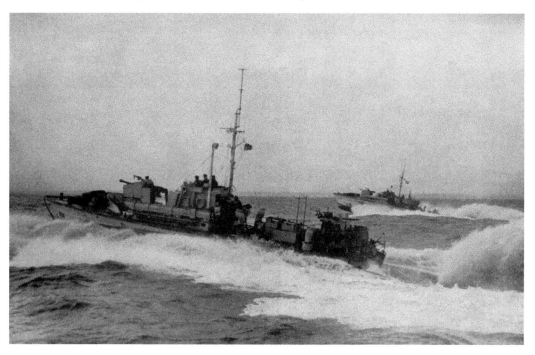

Motor torpedo boats at speed.

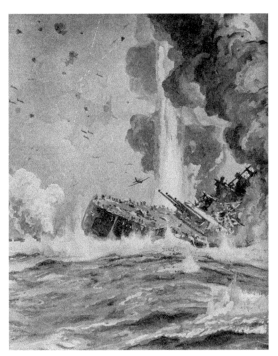

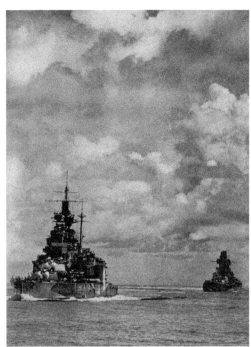

Above left: The battleship *Yamamoto*, arguably the most powerful warship in the world, left Japan's Inland Sea on 6 April, heading for the invasion beaches at Okinawa. Just a day later, she was sunk by American bombers. There were few survivors.

Above right: HMS *Valiant*, steaming ahead of the French *Richeliau*.

Below: A protecting destroyer leads the *Valiant* in a Pacific operation.

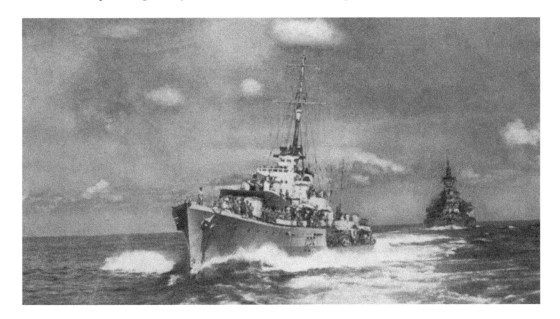

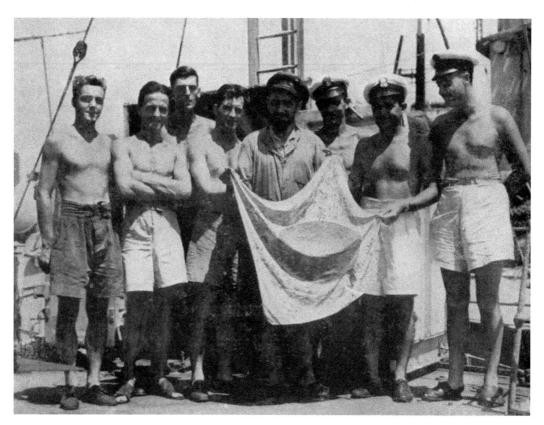

The crew of a Royal Navy destroyer pose with a Japanese flag they have captured.

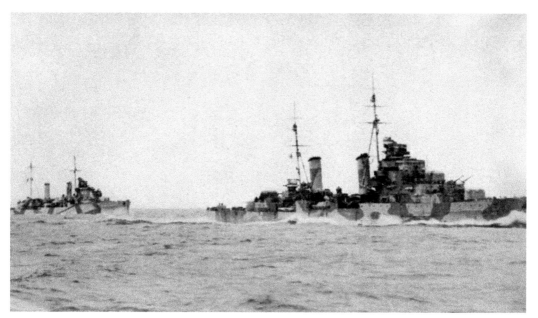

The cruiser *Euryalus* – sleek, fast and a powerful ship of war.

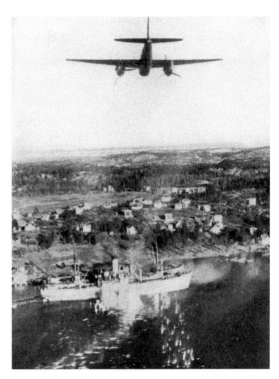

Mosquito aircraft attack German ships in the Sande Fiord.

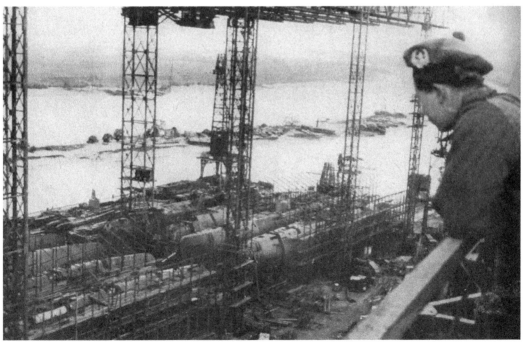

U-boats that were never completed. A Scottish soldier stares at captured U-boats, taken by the British when the docks at Bremen fell into Allied hands; these submarines could so easily have been put to use by the Germans, but the rapid advance of the Allies prevented their being commissioned.

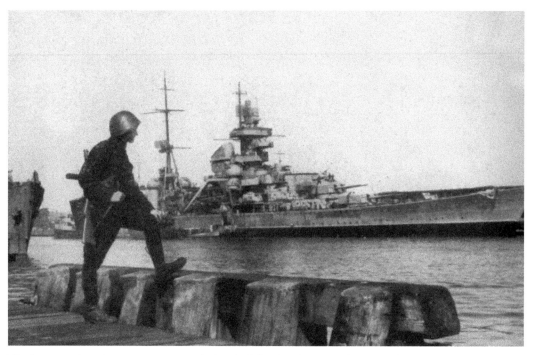

The heavy cruiser *Prinz Eugen*, a vessel that had fought alongside the *Bismark* against the *Hood*, suffered the ignominy of capture by the Allies. This shows her in dock at Copenhagen, guarded by a Danish sentry on her quarterdeck.

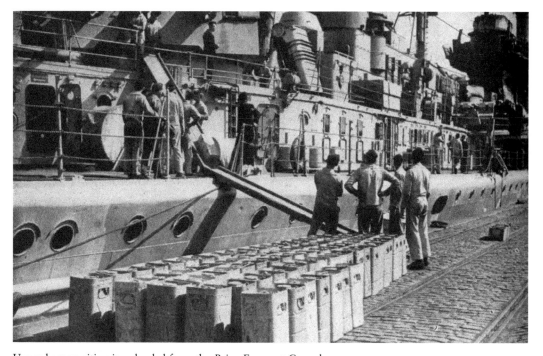

Unused ammunition is unloaded from the *Prinz Eugen* at Copenhagen.

Homecoming! The frigate HMS *Conn* arrives
back at her base.

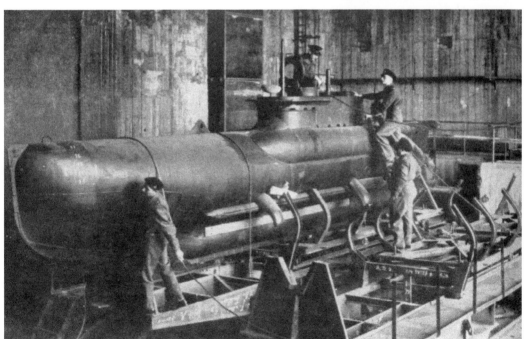

Captured German midget submarines.

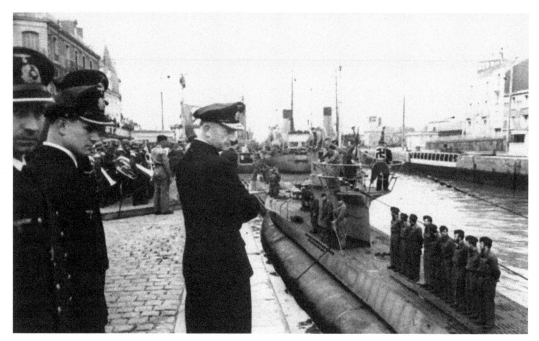

On 29 April, with the end rapidly approaching and with his nominated successor, Herman Goring, under arrest for treason, Adolf Hitler surprised everyone by appointing Karl Donitz to succeed him as head of the Third Reich. Donitz, ever the military man, accepted the position, even though it was a far cry from his previous duties.

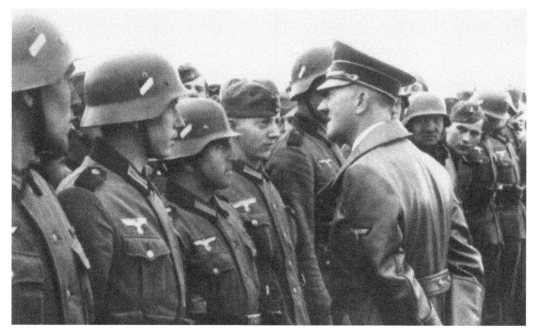

Hitler, shown here in 'happier' times, committed suicide on 3 April. His new wife, Eva Braun, died at his side.

The End of an Era

President Franklin Delano Roosevelt, a long-time supporter of Britain in its battles against Nazi Germany, died of a massive cerebral haemorrhage on 12 April.

Despite the fact that the US Congress and the majority of the American people were opposed to any form of help for Britain, from 1939 onwards Roosevelt had quietly, but significantly, provided as much aid and moral support as he could. It is not too sweeping a statement to say that, in the years after the fall of France, Roosevelt's support was instrumental in keeping Britain in the fight.

Roosevelt had been born in 1882, and by 1910 he was a Democrat politician, serving as assistant secretary of the Navy under President Woodrow Wilson. His world crumbled when, in 1921, he was diagnosed with polio. The debilitating disease left him paralysed from the waist down and, for a while, it looked as if his political career was over.

Roosevelt was a determined and driven man, however. He taught himself to walk short distances by using iron braces on his hips and legs, and by swivelling his torso. He used a wheelchair – but only in private. In public he sought to convince people that his health was improving.

It was a successful ploy and in 1933 he was elected president, the first of four terms in the Oval Office. When war broke out in Europe, Roosevelt was idealistically opposed to the right wing fascist powers and immediately began to turn America into an 'Arsenal of Democracy', providing weapons and munitions to the Allies. Of course, there was a charge, either in monetary terms or by the acquisition of bases in British-held territories. Nevertheless, it was vital help for a beleaguered Britain, help that Churchill, for one, was quick to acknowledge.

When Japanese forces attacked Pearl Harbour in December 1941, the USA entered the war. In a dramatic and popular speech that matched the rhetoric of Winston Churchill, Roosevelt called 7 December 'a date that will live in infamy'.

From that point on, Roosevelt was a committed and dedicated member of the coalition leading the fight against Germany and Japan. His death in April 1945, just a few weeks after he had been elected to a fourth term of office as president, was a bitter blow. Hitler, however, saw it as a miracle, something that would turn

the tide of war in his favour. He could not have been more wrong and within two weeks he had himself realised that defeat was inevitable and had committed suicide.

Roosevelt was succeeded by the inexperienced Vice President Harry S. Truman. The learning curve of the new president was steep, but he had the officials and administrators of the Roosevelt regime to aid him. Nevertheless, the death of FDR, as he was known, was undoubtedly the end of an era and there were many on the Allied side who were grateful that Roosevelt had not succumbed earlier in the war.

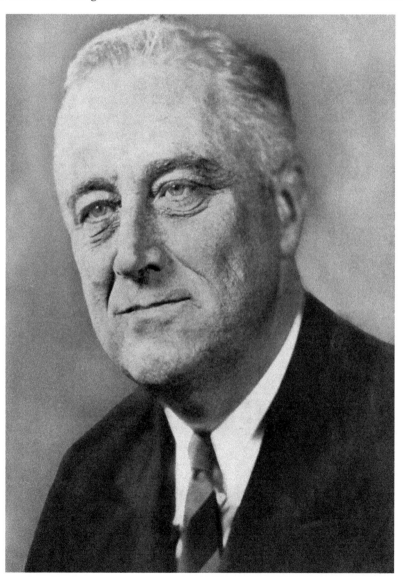

President Roosevelt, a dogged supporter of the Allied cause, did not live long enough to see Germany and Japan defeated. He died on 12 April 1945, a few weeks before the German surrender.

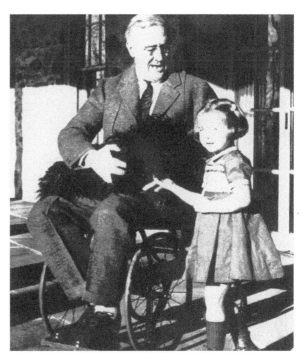

Roosevelt was careful to appear before the US public in the best possible light, meaning that photographs of him in his wheelchair remain rare. This image is one of the rarest, showing the president in his chair alongside Ruthie Bie, the daughter of the caretaker at his Hyde Park Estate.

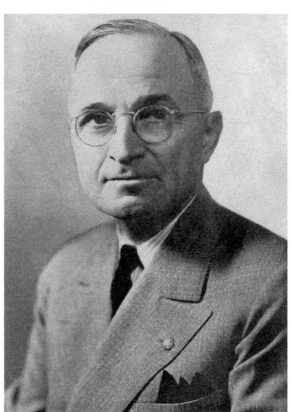

Harry S. Truman, as vice president, automatically succeeded Roosevelt following the president's death.

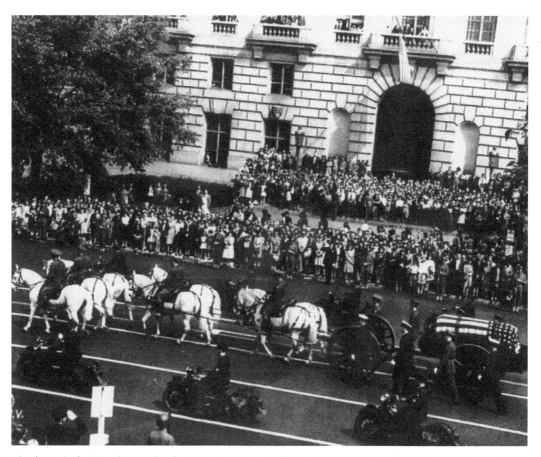

The funeral of FDR. Thousands of mourning Americans line the streets, and the cortege is escorted by motorcycle outriders.

May

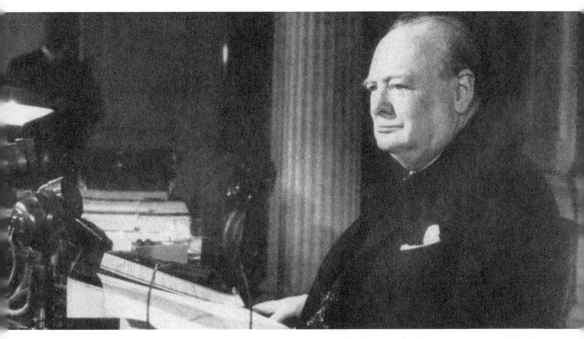

Winston Churchill broadcasts victory! Following Hitler's death and the Russian capture of Berlin, German surrender was inevitable. It was just a matter of time.

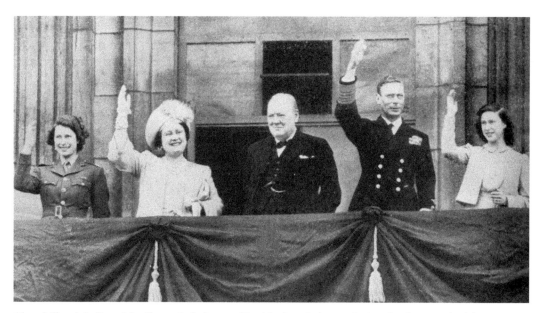

Churchill and the Royal family on the balcony of Buckingham Palace, enjoying the cheers and adulation of the crowd. VE Day (Victory in Europe Day) was celebrated on 8 May.

The last of the silent killers – the U-boats – surrender. The final U-boat victory had come on 7 March when *U-2336*, one of the few German submarines still operating, claimed one last cargo vessel.

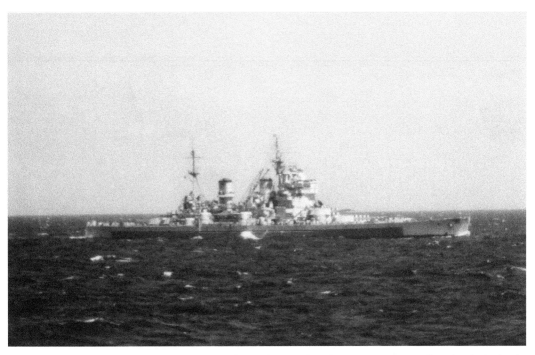

The *King George V* – one of many powerful battleships that, by 1945, were virtually redundant, thanks to the advent of air and submarine power.

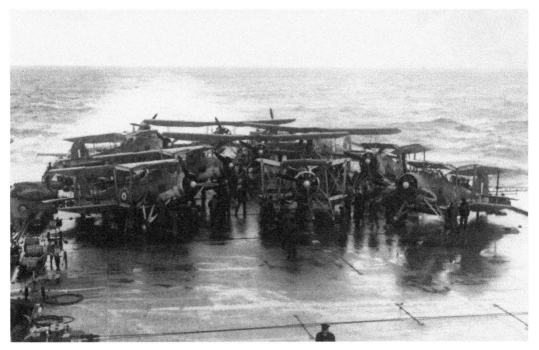

Victory at sea had been hard won, but the success of the Allies was down to air power rather than surface ships.

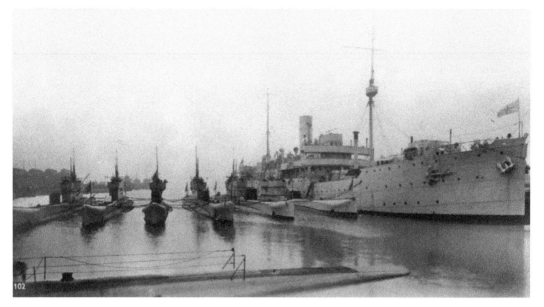

Submarines had also been instrumental in the German defeat. The activities of Royal Navy submarines are less well known than their German counterparts, but British submariners fought a long and bitter battle against the enemy. This shows British subs lying peacefully alongside their depot ship.

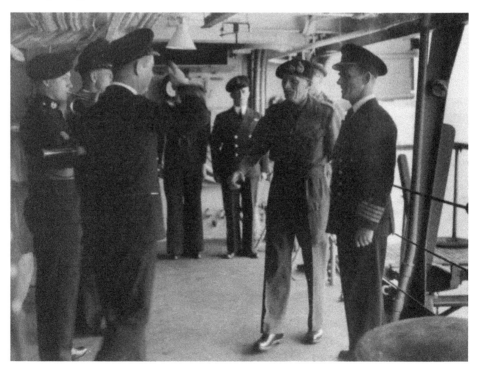

General Montgomery, the man who had taken the initial German surrender on Lunenburg Heath, comes on board a British warship.

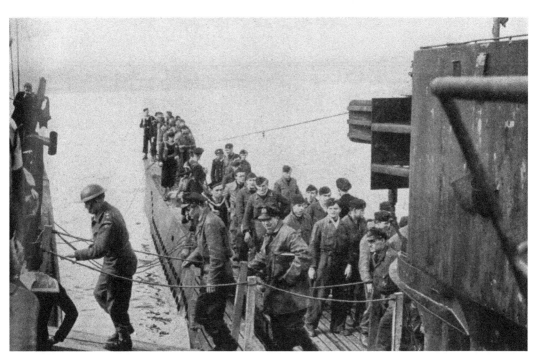

The crew of *U-249* walk into captivity. *U-249* was the first German submarine to sail into British waters as a captive when she entered Weymouth Harbour.

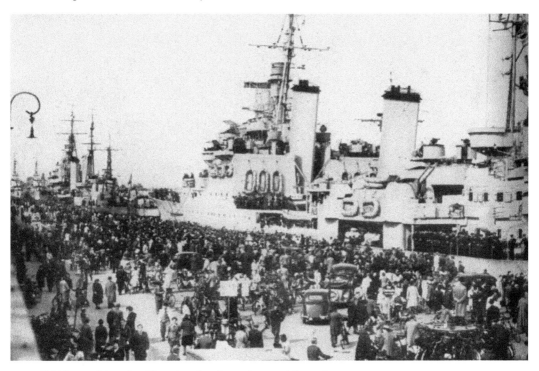

British warships after liberating the city and port of Copenhagen.

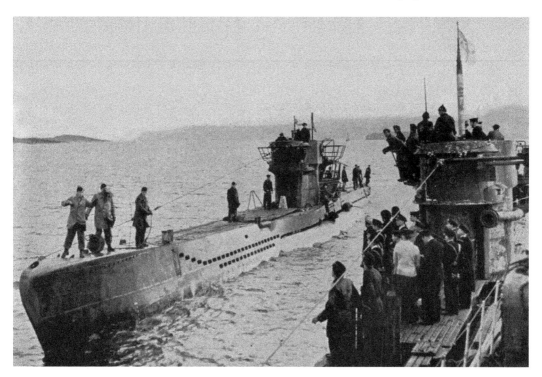

U-boats surrendering at Loch Eriboll in Scotland. The *U-236* is just coming alongside *U-826*. The White Ensign shows that the submarines are now in British hands.

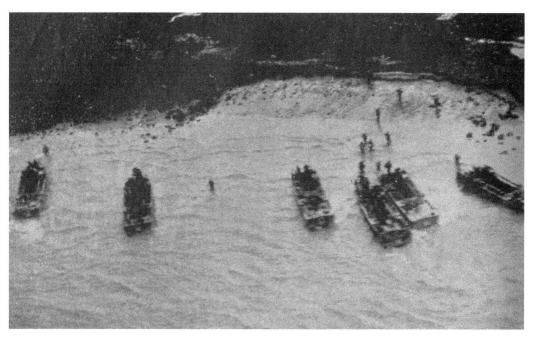

The war in the East continued. Here British and Indian troops are seen coming ashore at Rangoon from barges, May 1945.

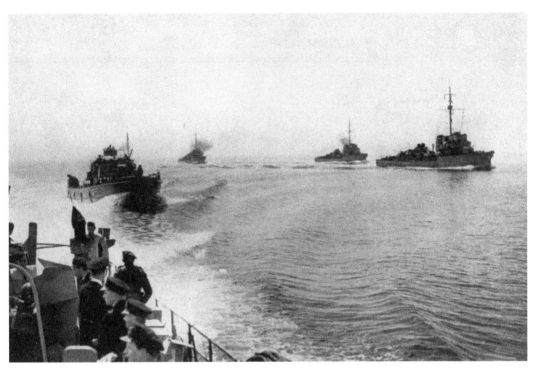

German minesweepers in the act of surrendering.

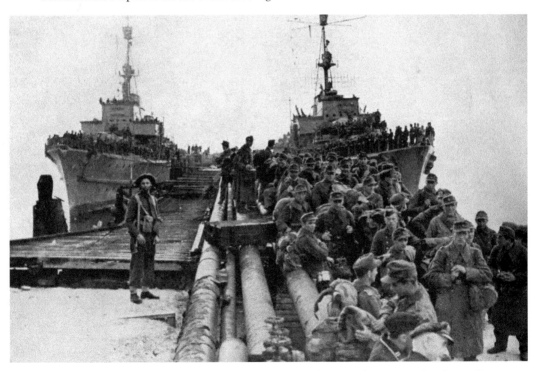

The Royal Navy at Kiel, discharging prisoners who are no longer a danger now that the conflict is over.

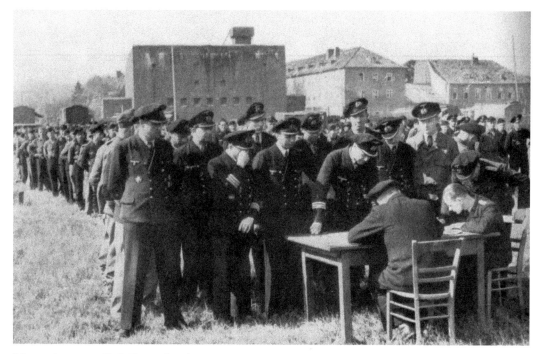

More prisoners at Kiel. Here, after their capture, German U-boat men give their names and numbers to British forces.

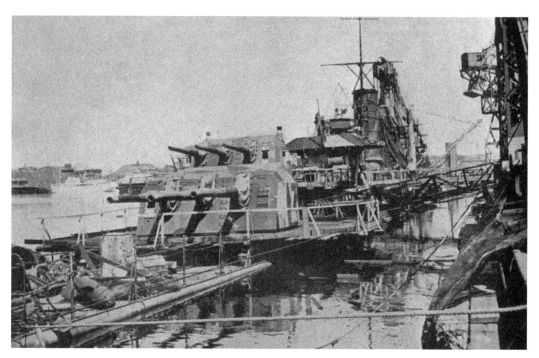

The sad remains of the once-proud cruiser *Koln*, bombed and destroyed at her moorings, rest on the bottom of the harbour at Wilhelmshaven.

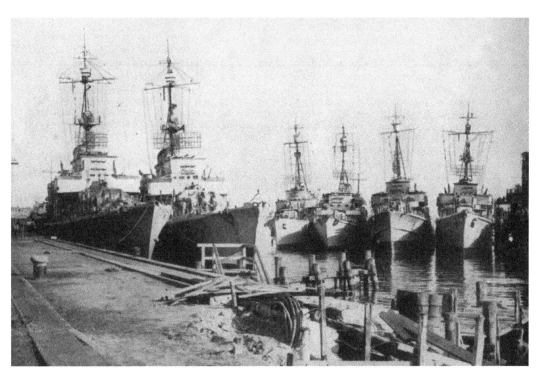

The remains of the German surface fleet at Kiel.

Keeping the armies in France and Germany supplied with fuel, oil and ammunition was a major logistical problem. One solution was to lay a pipeline, 'PLUTO', as it was known, under the Channel between England and the Continent.

June

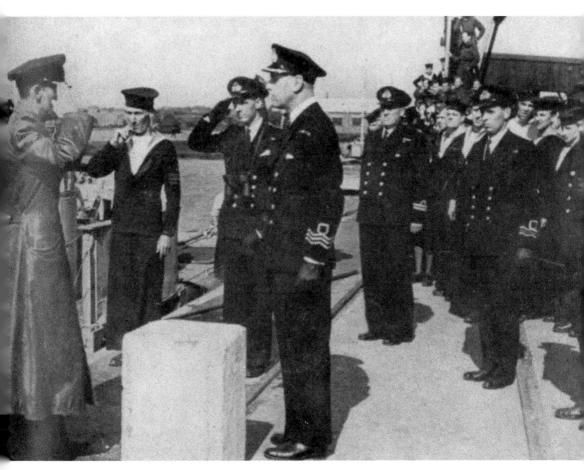

The war in Europe might have ended, but gathering in prisoners and enemy shipping took time. This shows Rear Admiral Bruening, commander of the E-boat fleets, surrendering at Felixstowe.

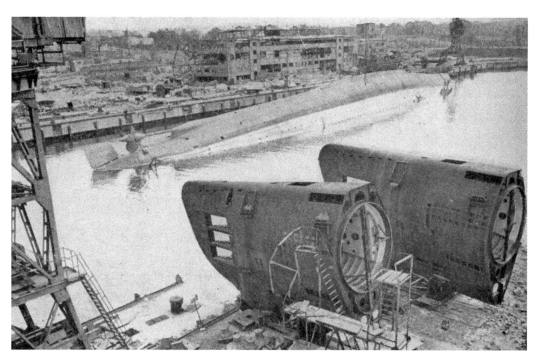

Captured E-boats are escorted into Felixstowe by a flotilla of MTBs.

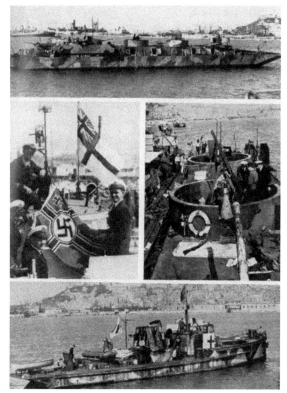

The surrender of Germany's 'little ships'. The E-boat war had been a hard-fought campaign, with British MTBs and German E-boats hurling cannon shells and torpedoes against each other, night after night. Now the battles were finally over.

The battleship *King George V*, seen from the deck of an accompanying aircraft carrier.

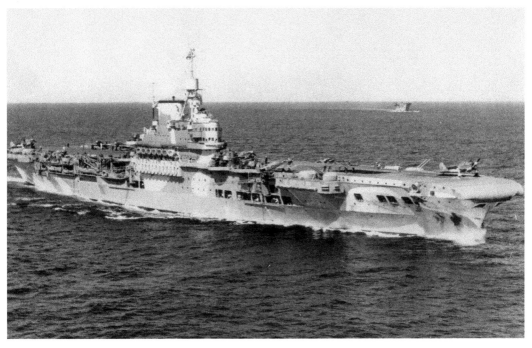

The carrier *Victorious*, one of many British ships sent to assist the Americans in the war in the Pacific.

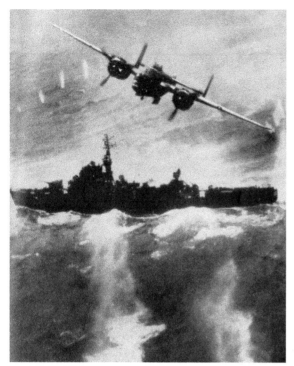

The war in Europe might have ended, but Japan continued to fight on. This shows a Japanese destroyer under attack from US aircraft.

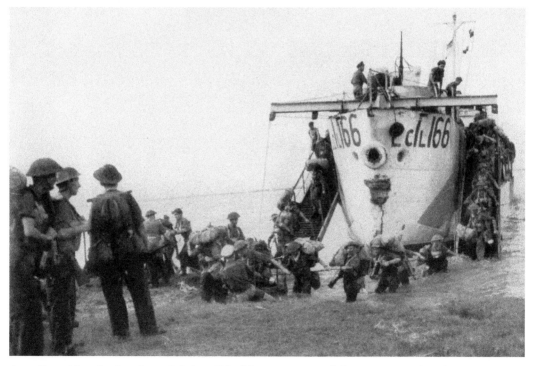

As well as aiding the Americans, Britain still had her own war to fight in Burma and Malaya. Here, members of the RAF Regiment come ashore at Rangoon.

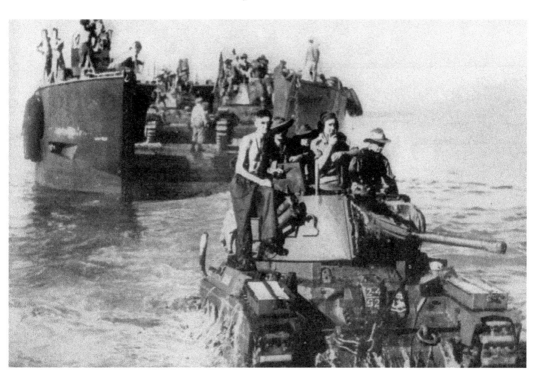

Australian Matilda tanks leave their American-built LCTs.

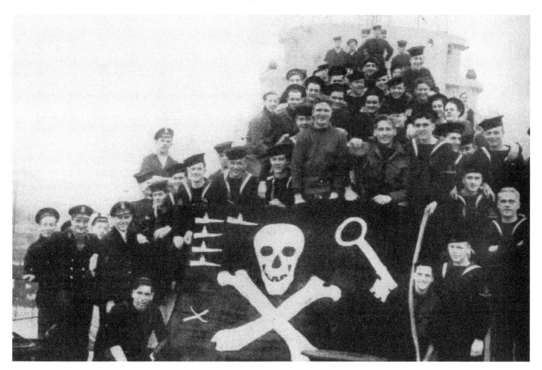

The crew of a British frigate.

A petty officer from the Royal Naval School
of Malaria and Hygienic Control uncovers
a stagnant pool that could easily harbour
malaria bugs.

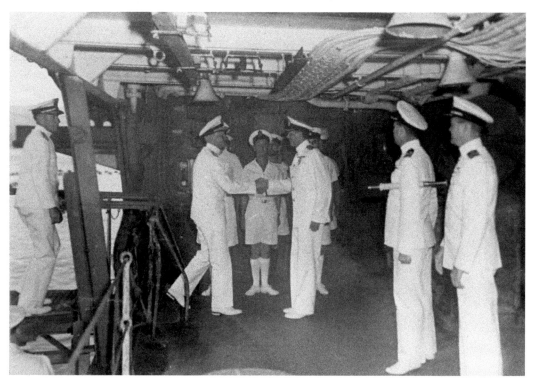

US Admiral Chester Nimitz goes on board the *Victorious* at Pearl Harbour.

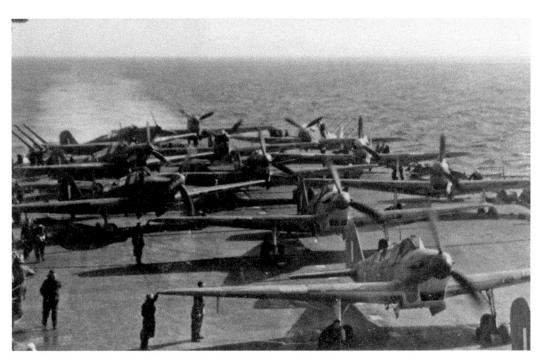

Seafires lined up on the deck of a carrier at sea.

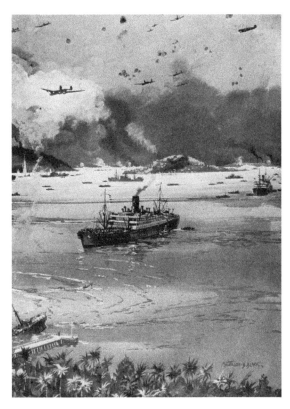

Australian forces landing on the coast of
North Borneo, 10 June 1945.

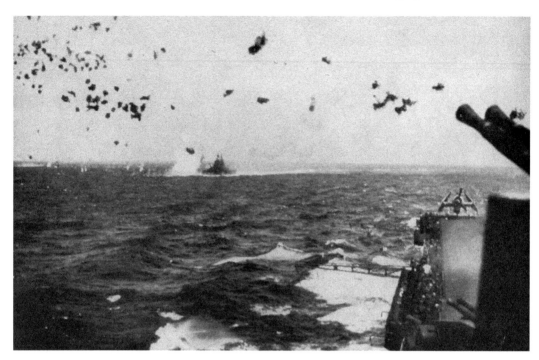

Japanese kamikaze attacks continued almost to the end of the Pacific war. This shows one kamikaze fighter that did not hit its target.

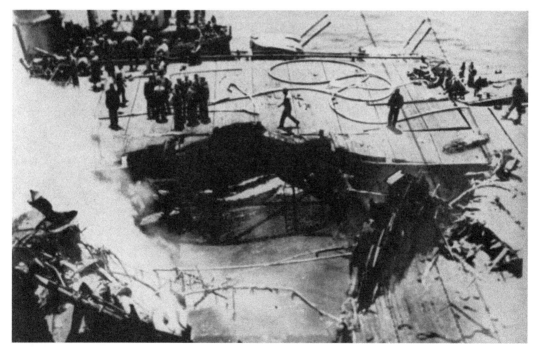

A gaping hole in the flight deck of the USS *Bunker Hill* shows the damage that kamikaze pilots could achieve if they were not shot down before hitting their target.

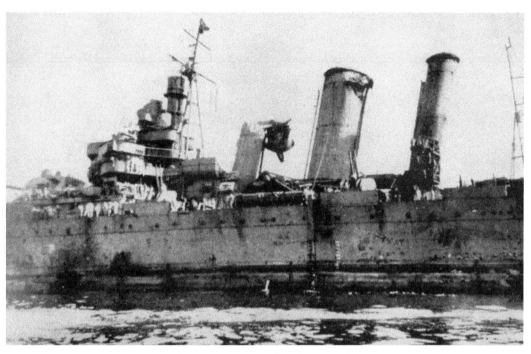

Damage to the cruiser *Australia* after yet another kamikaze attack.

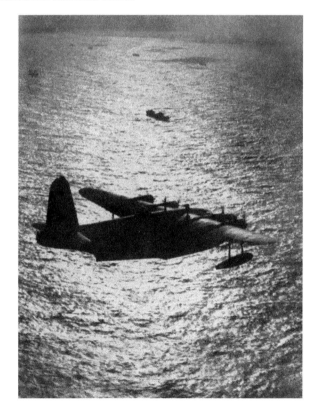

A Sunderland flying boat, one of the main weapons in defeating the U-boat menace, cruises over a convoy as evening closes in.

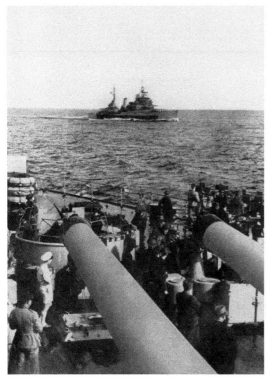

The cruiser *Gambia*, photographed from the battleship *Howe*.

Peace or war, there was always work for sailors to do – such as washing the deck of HMS *Howe*.

The guns of the *KGV*, with Admiral
Nimitz posing beneath them.

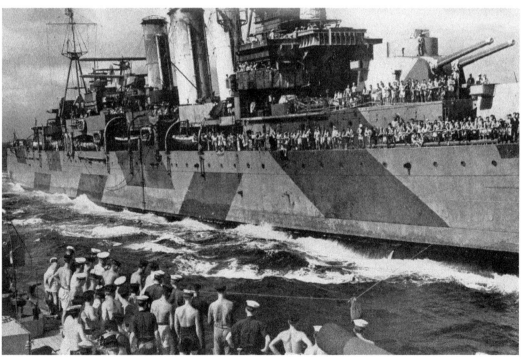

HMS *Devonshire* passes mail to the *Mauritius*.

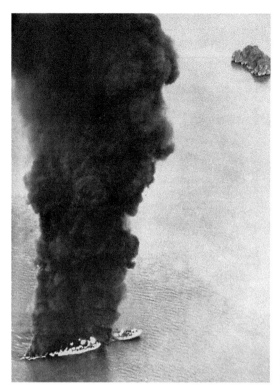

A Japanese ship, on fire and about to sink. The photograph was taken from an RAF Liberator bomber.

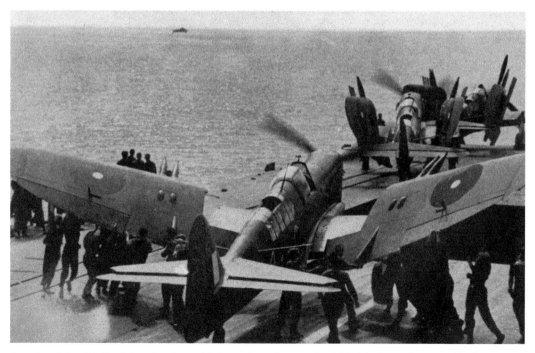

A rocket-firing Firefly fighter/bomber, with her wings about to be folded before taking the lift down to the hangar.

July

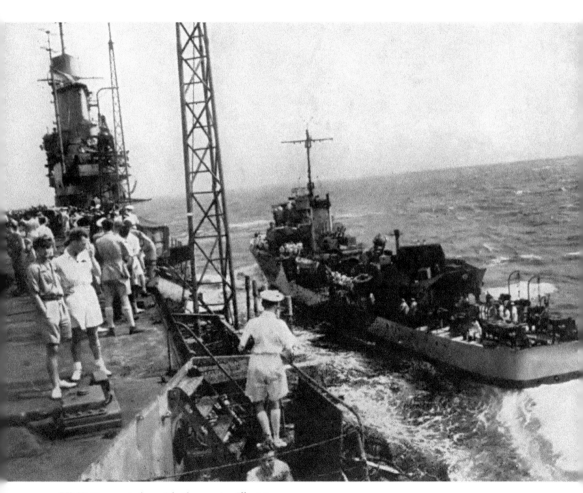

HMS *Derwent* alongside the carrier *Illustrious*.

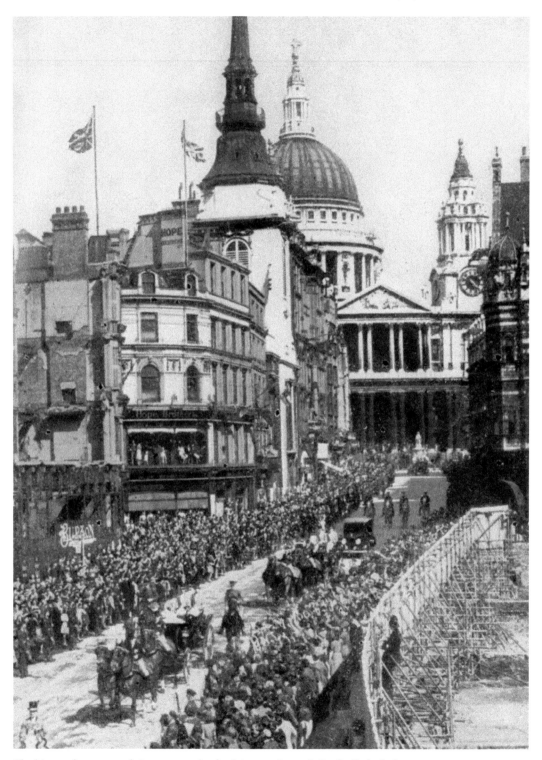

The king and queen on their way to a thanksgiving service at St Paul's Cathedral.

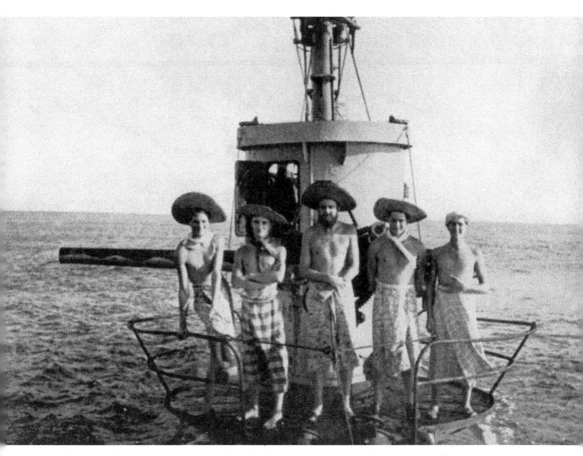

The crew of an Allied submarine take a little leisure time, dressed in native costume.

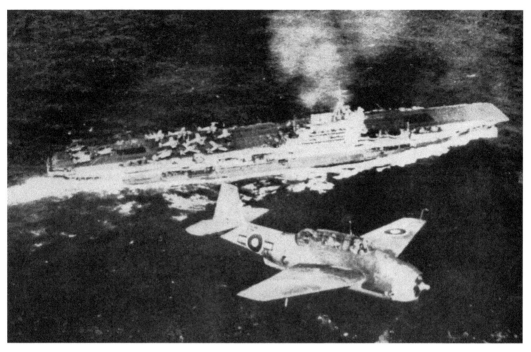

An Avenger fighter/bomber over the carrier HMS *Indomitable*.

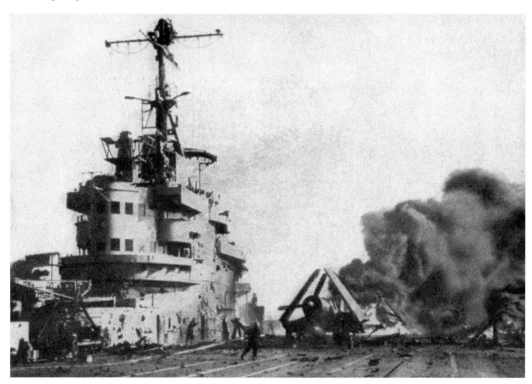

A British carrier hit by a kamikaze raider.

Setting the sea on fire! A desperate ploy to defend land bases from enemy attack – strips of oil are laid on the sea, ready to be set on fire if enemy landing craft ever approach.

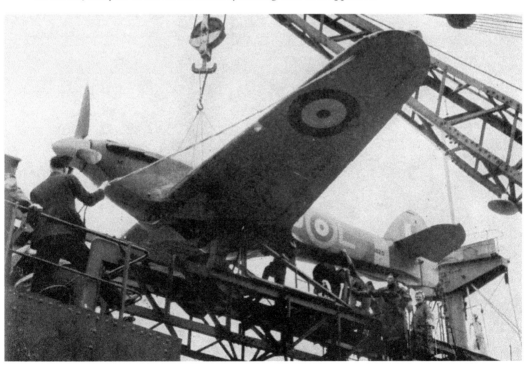

A Hurricane fighter, ready to be catapulted off a merchant vessel.

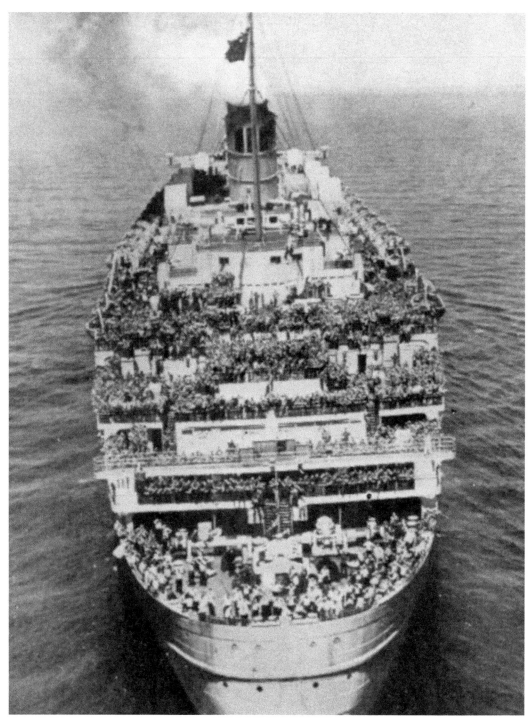

The war in Europe having ended, US troops quickly began to redeploy, some simply going home, others re-mustering for potential campaigns in the Pacific. This shows the liner *Queen Mary* arriving in New York with 14,000 GIs on board.

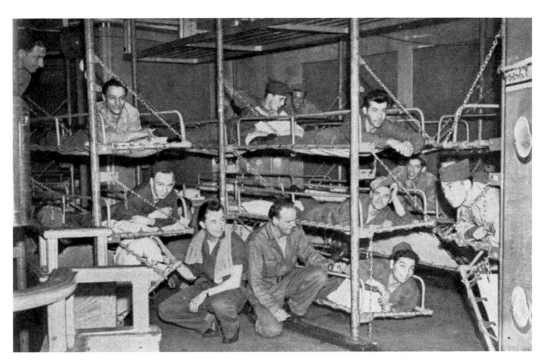

Accommodation for GIs on board the *Queen Elizabeth*. Both of the 'Queens' were used to take American soldiers back to their homeland.

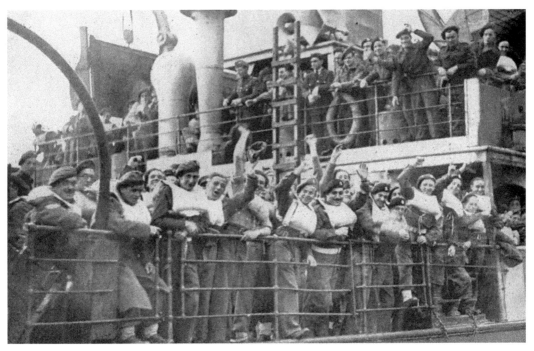

British soldiers returning home on their troop ship – unlike the Americans, they did not exactly enjoy the heights of luxury, something which annoyed the men considerably.

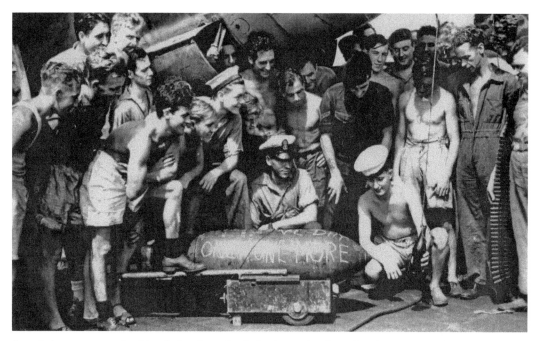

Scrawled messages on the side of a bomb on the deck of a carrier show that the crew were happy to be coming to the end of service overseas, even though the exact date for a return home was still unknown.

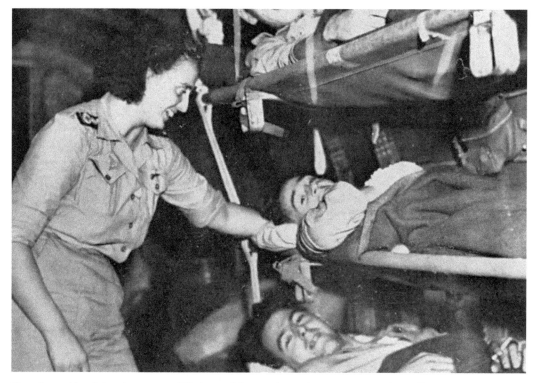

Complete with ministering nurses, Allied casualties are shown here en route to Australia.

Getting Back to Normal

Getting back to normal was something everybody wanted, from the homesick soldiers and sailors who warbled 'We'll Meet Again' in their billets or mess decks every night to the members of Churchill's wartime coalition government, who wanted nothing more than a return to party politics. Now, with hostilities in Europe ended and the war against Japan rapidly reaching a climax, it seemed as if a return of the status quo would, indeed, soon be possible.

Just as the outbreak of war had caused disruption in British society, so, too, did an end to the conflict in Europe. And it was not just Britain that was affected. British colonies such as India, Burma and Singapore were eager for peace, not least because they were intent on independence and self-government. American GIs, who had arrived in their thousands in the months and years after December 1941, were desperate to return to the USA, where they could resume their lives with wives and girlfriends.

Britain, which had been bombed and battered by the Luftwaffe, needed time and the opportunity to rebuild its infrastructure. Firms and businesses were in desperate need to develop and people wanted houses to replace the ones that had been destroyed. The inevitable surplus supply of tanks, ships and weapons once the war ended provided an opportunity that many entrepreneurs felt they could not miss.

The end of the war in Europe was, for many, a rare opportunity. It was a chance to start life again. For some, however, the traumas of the past six years were just too great and, for them, getting back to normal was an option that was never even remotely possible.

As with all conflicts, the war had led to significant developments that might otherwise have taken dozens of years to come to fruition. As Harry Lime in the film *The Third Man* was later to comment, 'In Italy for 30 years under the Borgias they had warfare, terror, murder, and bloodshed, but they produced Michelangelo, Leonardo da Vinci, and the Renaissance. In Switzerland they had

brotherly love – they had 500 years of democracy and peace, and what did that produce? The cuckoo clock.'

By 1945 the day of the large capital ship, vulnerable to sudden attack from the air and from below the surface of the sea, was clearly over – aircraft carriers were now the most important vessels in any fleet. Admiral Yamamoto knew as early as 7 December 1941 that the war was lost when his attacking aircraft failed to find and destroy the American carriers, which, by sheer luck, were out of Pearl Harbour that morning.

By the end of the war, submarines could travel huge distances while submerged, the development turning this deadly but unseen weapon into a truly global threat. Drugs like penicillin, long-distance air flights, weapons that were more deadly than anyone could ever have imagined in 1939 – the list is endless.

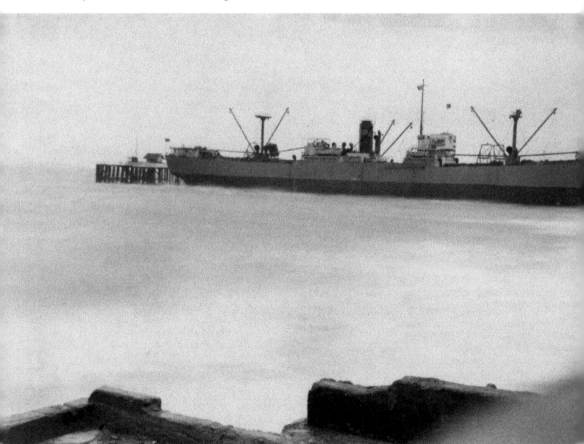

With hostilities almost at an end, hundreds of hastily constructed Liberty ships became available for use by private shipping companies. For several years after 1945, vessels like the *Port Royal Park*, shown here at Penarth in South Wales, continued to sail the waterways of the world.

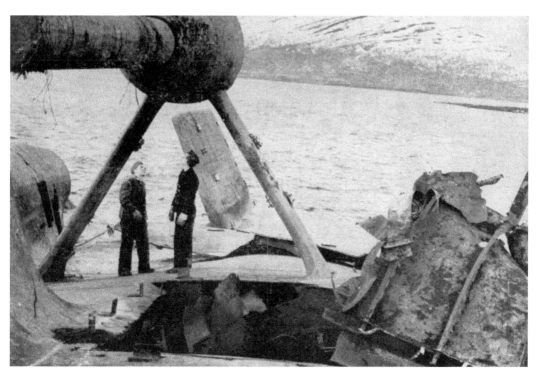

With the Germans pushed out of Norway and other captured territories, Allied forces were at last able to see the effects their bombs and shells had made in the war years. This 1945 view shows men standing on the capsized hull of the once-mighty *Tirpitz*, destroyed in her fiord only twelve months before.

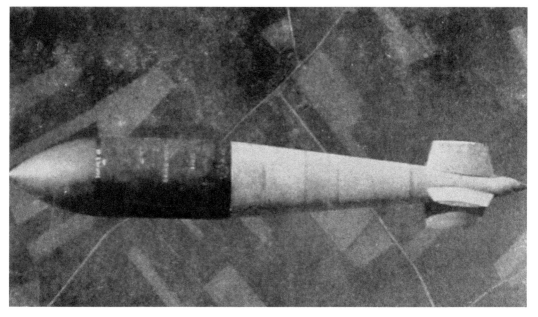

A 'tallboy' bomb is dropped. This and several more 12,000-ton bombs were the weapons that finally sank the *Tirpitz*.

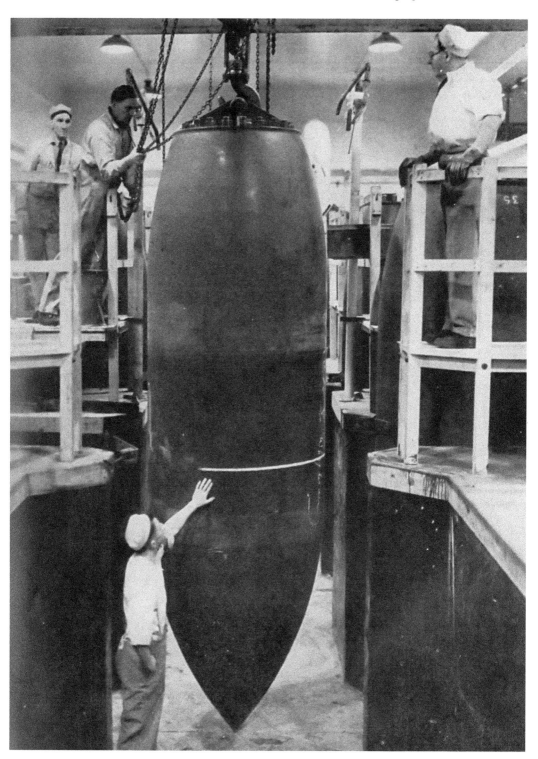

Never an easy task, ground crew manoeuvre a 22,000-lb bomb to its waiting aircraft.

The USS *Philadelphia* arrives in European waters, carrying President Truman. He has come to take part in the Potsdam Conference, which begins on 17 July. The conference, which includes all the major Allied leaders, is Clement Attlee's and Truman's first major international meeting, and will decide the way the post-war world will be managed.

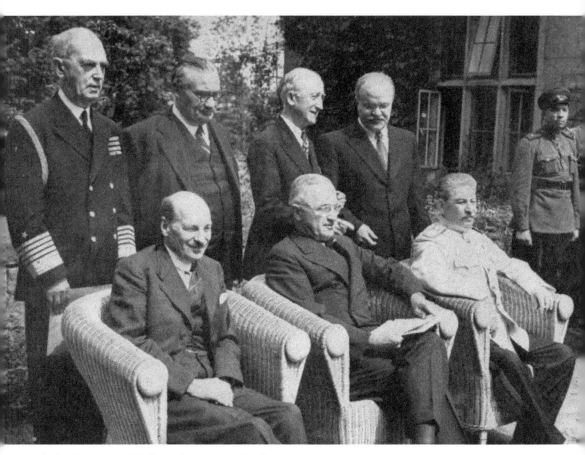

Attlee, Truman and Stalin at the Potsdam Conference.

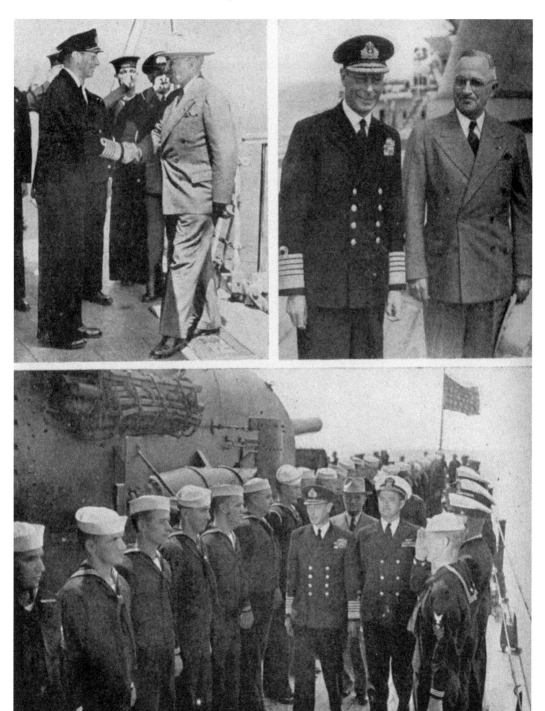

President Truman, on his way back from the Potsdam Conference, stopped at Plymouth, where he was met by King George. Truman inspected sailors on the *Renown*, while the king returned the compliment with an inspection of American sailors on the USS *Augusta*, which was taking Truman back to the US.

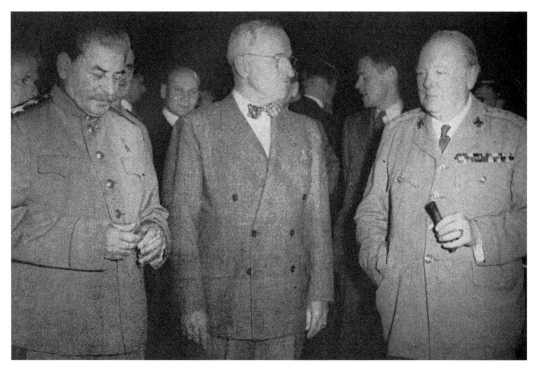

Stalin, Truman and Churchill at the Potsdam Conference, July 1945.

British warships in close contact.

British warships – the cruiser *Belfast*, battleship *Royal Sovereign* and escort carrier *Begum*.

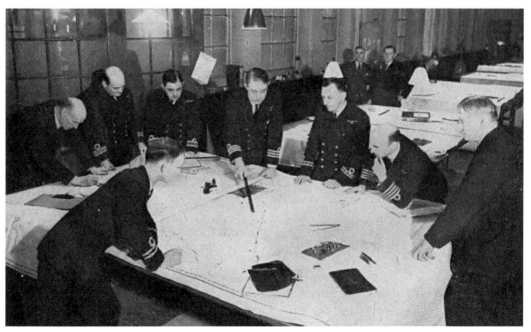

The logistics of planning and making moves for the hundreds of Royal Navy ships across the world was a complicated process. This shows the plotting room at the Admiralty, where convoy routes and the journeys of individual ships were monitored.

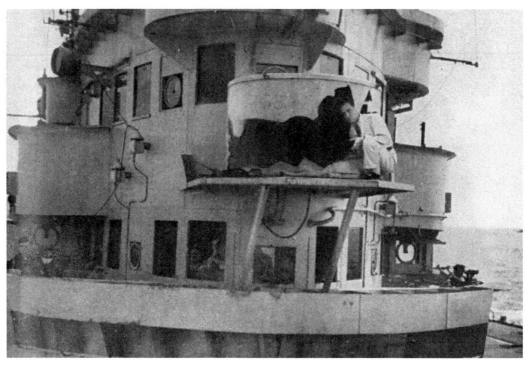

Damage to the aircraft carrier *Illustrious*, hit by a kamikaze plane in the final months of the Pacific war.

Japanese soldiers and sailors rarely surrendered, as their code of honour would not allow it. Sometimes, however, they were taken by surprise and had no option but to become prisoners, as this photograph shows.

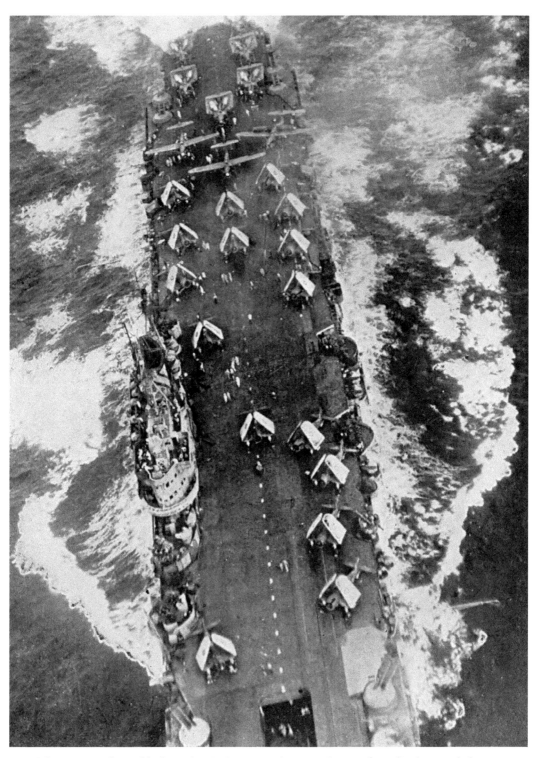

The carrier *Indomitable*, from the air. Corsairs and Barracuda aircraft are lined up on deck.

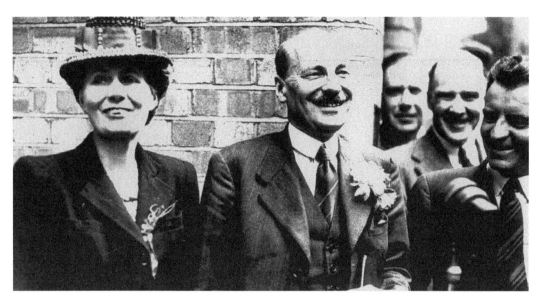

With Germany beaten and the Conservative party totally confident of victory at the polls, Churchill called what was known as the 'Khaki Election' in July 1945. Voting was not limited to the UK, as men serving in Burma or on the ships of the British Pacific Fleet all cast their votes. To the amazement of everyone, Labour won 393 seats (to the Conservatives' 213) and on 26 July Clement Attlee replaced Churchill as prime minister. He is shown here with his wife once the results had become known.

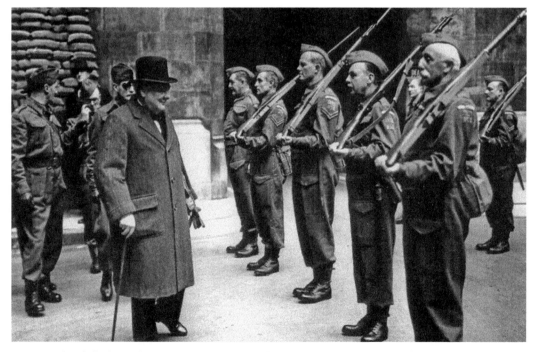

Winston Churchill, shown here inspecting members of the Home Guard, may have felt rejected by the British people, but Labour's promise of a welfare state was too good an opportunity to miss. Members of the armed forces and the general public expected a better world after the sacrifice of so many years.

Minesweeping launches of the Royal Navy.

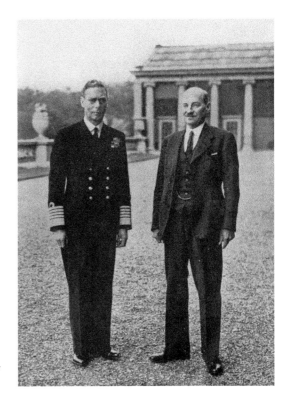

After the euphoria of VE Day, it was now all change. The king is shown here with new Prime Minister Clement Attlee.

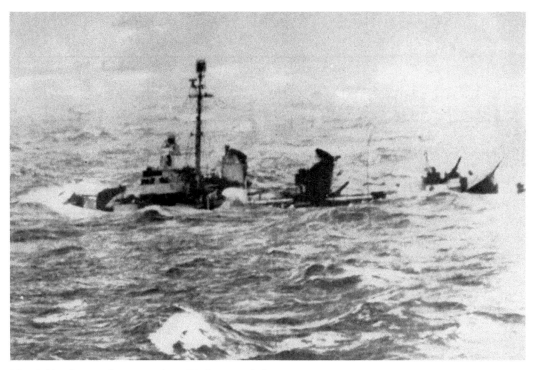

Not sinking but nearly swamped – a US destroyer in heavy seas.

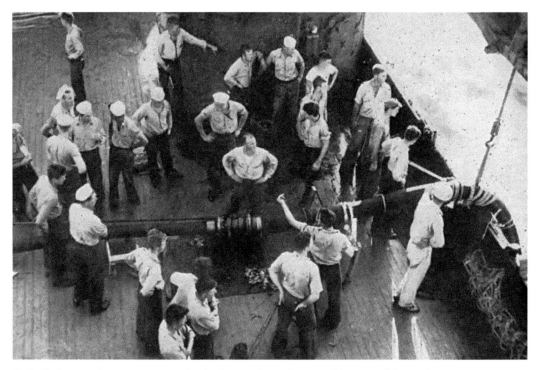

Fuel oil, the most important commodity in the naval war, is pumped into a waiting cruiser.

August

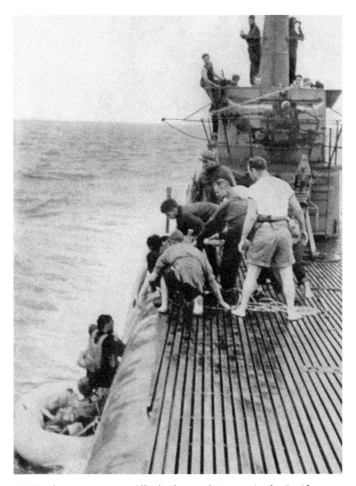

A US submarine rescues Allied pilots and aircrew in the Pacific.

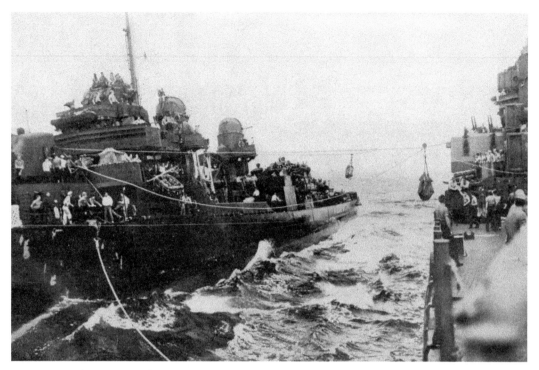

An American destroyer transfers wounded Marines to the cruiser *Santa Fe*.

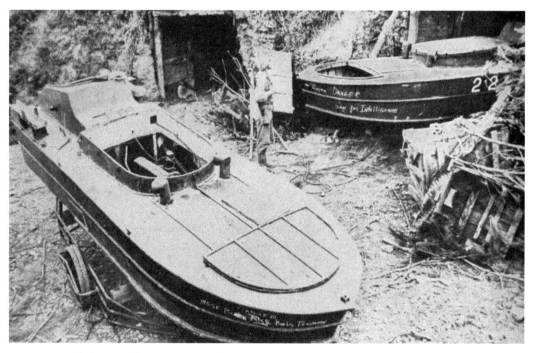

Japanese suicide boats, seaborne versions of the kamikaze raiders – captured on Okinawa and never used by the Japanese defenders.

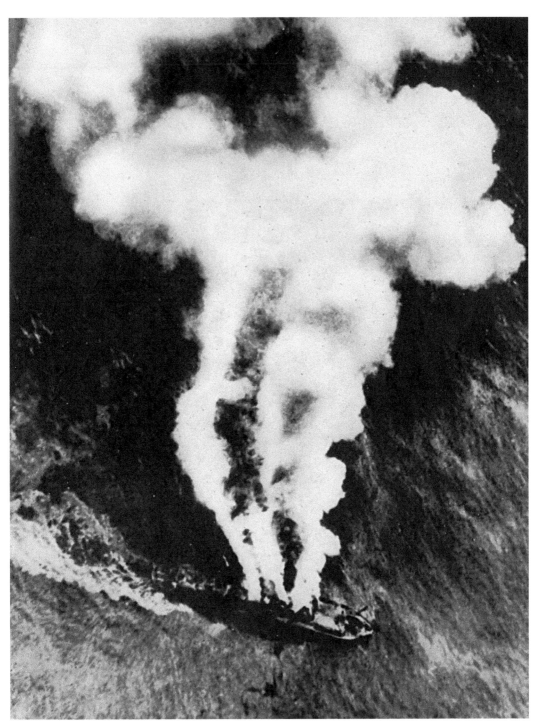

Both the Americans and the Japanese knew that the war could not last much longer, but the Japanese army and navy continued to fight with fanatical desperation. This photograph shows a Japanese ship being attacked and destroyed by US aircraft in the Tsugaru Straits.

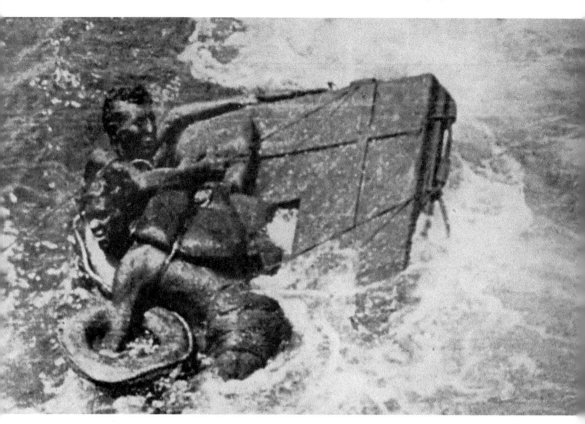

Japanese sailors being rescued by American submarines.

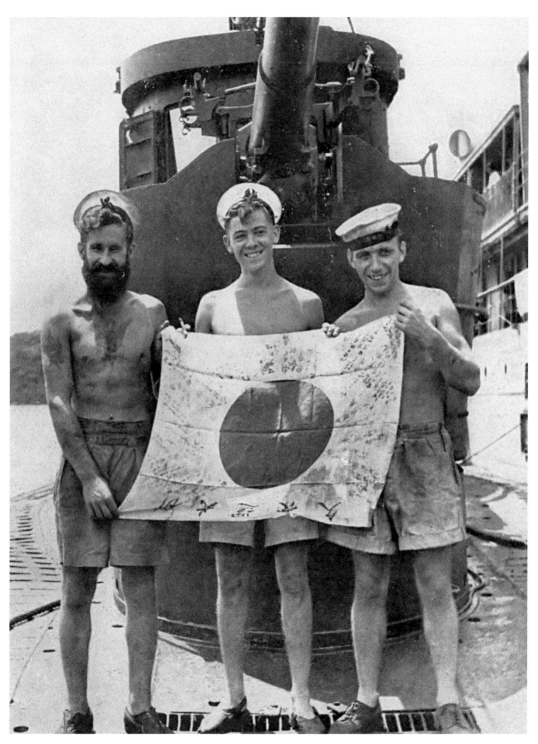

Three crewmen from the submarine *Trident* are shown here, triumphantly posing with a captured Japanese flag.

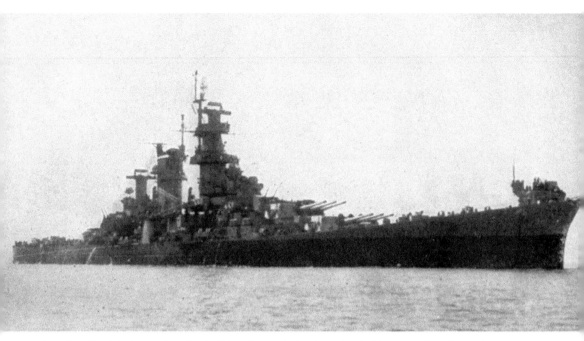

America, like Britain, continued to build and commission large battleships, even though naval planners knew that the days of the capital ship were over. This shows the brand new USS *Guam*.

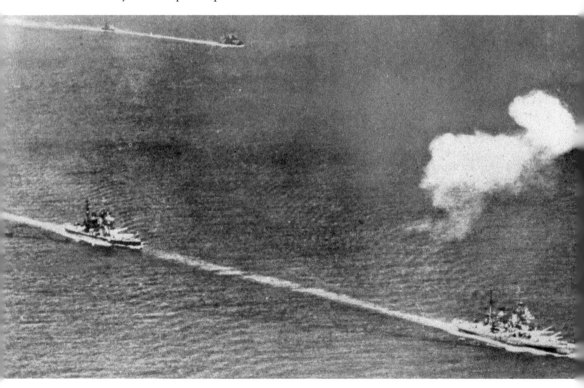

British forces bombard targets in Malaya.

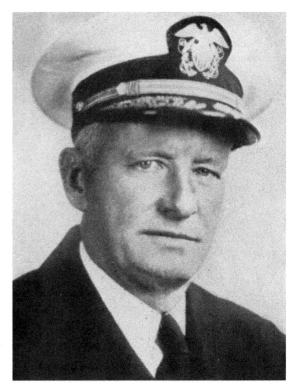

Admiral Chester Nimitz, Commander-in-Chief of the US Pacific Fleet. Nimitz did not know it at the time but, in 1946, he would be called to give evidence at the Nuremberg War Crimes trials where he was forced to admit that, like Admiral Donitz, he employed a policy of 'no aid' to Japanese sailors whose ships had been sunk.

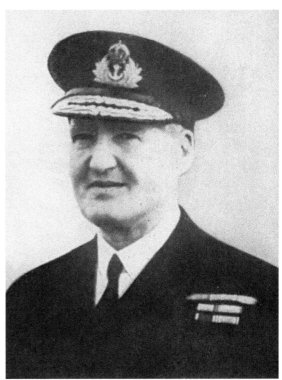

Admiral Sir Bruce Fraser, Commander-in-Chief of the British Pacific Fleet.

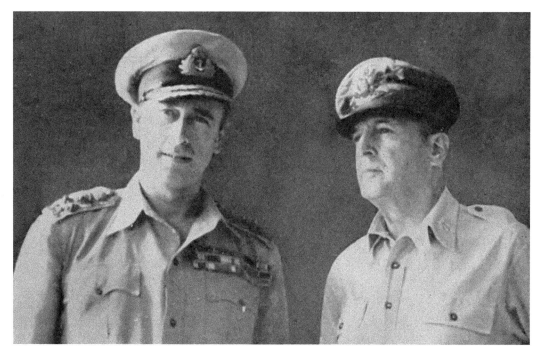

Admiral Louis Mountbatten, Supreme Allied Commander in the Far East, meets his American counterpart General Douglas MacArthur.

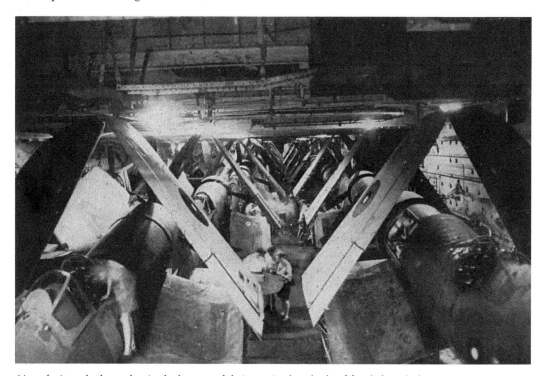

Aircraft sit packed together in the hangar of their carrier, hundreds of feet below deck.

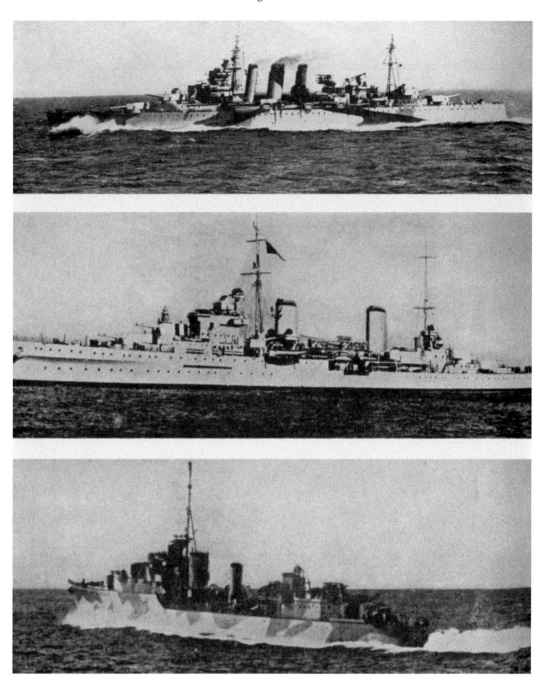

A composite view of Australian warships that fought in the Pacific campaign.

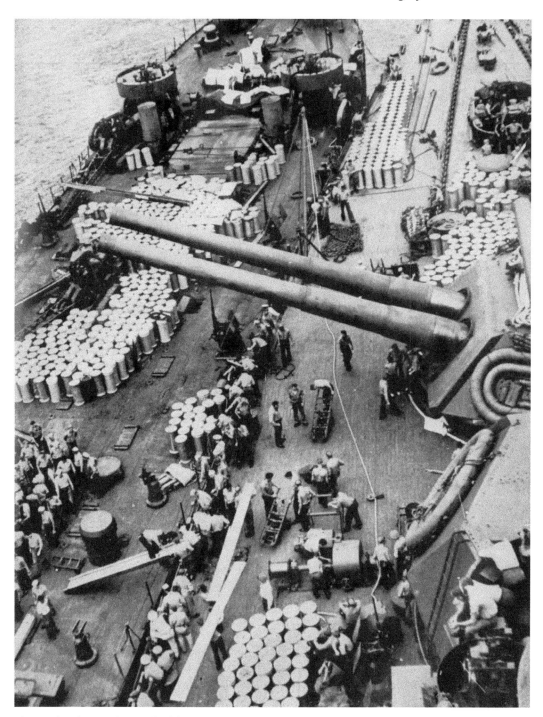

The need to keep sailors and soldiers well supplied with food and medical provisions was obvious, perhaps more so in the US navy than anywhere else. Landing craft, when not disgorging Marines onto invasion beaches, were ideal craft to take on this duty. This shows an American landing craft alongside a US warship, transferring supplies.

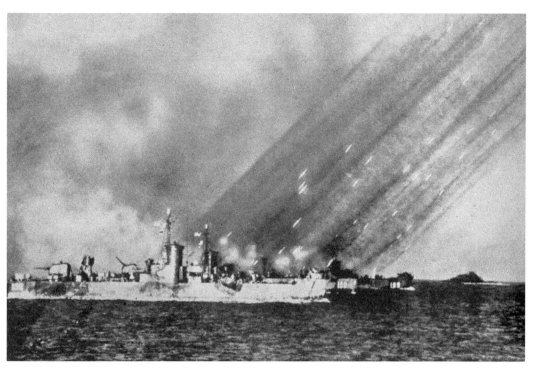

The war goes on – rockets launched are against Japanese positions.

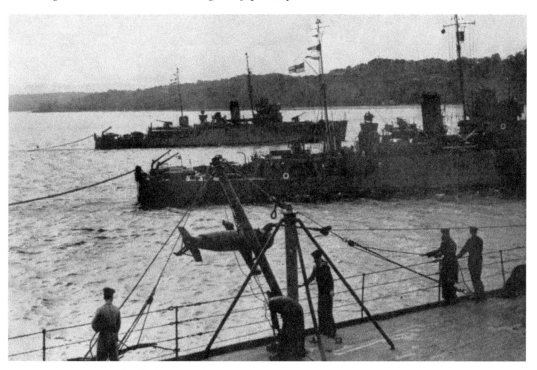

A minesweeping flotilla lies peacefully at anchor.

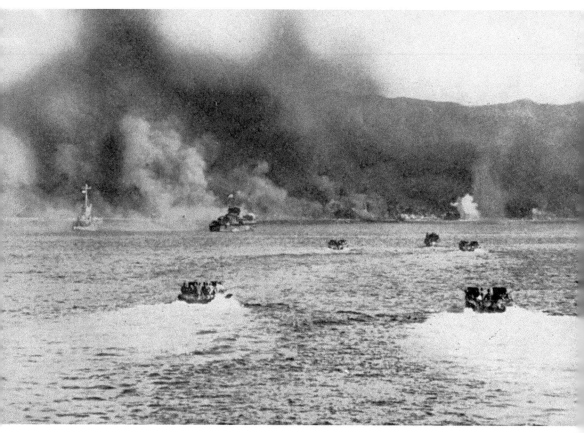

Not all of the Japanese-held islands offered the resistance of Okinawa. This shows American landing craft approaching Cebu Island after the defences had been 'softened up' by a preliminary naval barrage. The island and its troops offered little opposition.

The End of It All

Harry S. Truman became the thirty-third president of the US after Roosevelt's death in April 1945. He was immediately confronted with a dilemma – to use or not use atomic weapons against Japan. Until he became president, Truman had not even known that such weapons existed. Now he had to make the most crucial decision of his life.

Not for nothing did Truman have the motto, 'The buck stops here', in a frame on his desk. It was his decision – and his decision alone – as to whether or not to use atomic weapons. The alternative was an invasion of the Japanese homeland, something that the Japanese, civilians and soldiers alike, would resist to the death. More importantly, such a proposed invasion would undoubtedly lead to the death of thousands of American soldiers and sailors. Faced by the possibility of massive casualty figures, American and Japanese alike, there could only be one decision.

The world's first atomic bomb was duly used against the city of Hiroshima at 8.15 in the morning of 6 August. The uranium-235 fission bomb was dropped from the B-29 *Enola Gay* – named after the pilot's mother – creating an explosion equivalent to 20,000 tons of TNT. Cloud cover prevented the Americans from observing the full effect of the bomb, but everybody on the *Enola Gay* and the escorting aircraft knew that it was significant moment in the war.

More than 80,000 people were killed and much of Hiroshima utterly destroyed. Buildings were reduced to rubble and civilians vaporised in moments. Thousands more people suffered illness and death from radiation sickness and other debilitating ailments in the years ahead. The long-term effects of atomic warfare were barely understood at the time. Whether or not an awareness of these terrible side effects would have affected Truman's decision remains imponderable.

Although more damage and destruction had been caused by a recent 'carpet bombing' attack on Tokyo, Japanese radio denounced the use of this new weapon, which was terrifying in its intensity and destructive powers. The attack was likened to the raids of Genghis Khan, the Japanese conveniently forgetting their own brutalities earlier in the war.

Two days after the bomb fell from the *Enola Gay*, Russia declared war on Japan and duly sent its armies into Manchuria. The sense of an imminent end to the war

began to pervade every debate and discussion – on both sides. Bombardment of Japan and the home islands by ships of the US Pacific Fleet continued, adding to the misery and feelings of disaster in Japanese civilians.

Despite these feelings, there was no immediate offer to surrender by the Japanese government. Consequently, a second bomb was dropped, this time on the city of Nagasaki, on 9 August. This time 40,000 were killed, although the devastation was not as widespread as occurred in Hiroshima. While Truman informed the Japanese that unless there was immediate surrender more bombs would be dropped, in reality the Americans did not actually have any more atomic bombs ready for use.

The bluff worked but it took a radio broadcast by the Emperor – the first time most Japanese had ever heard his voice – to convince people that surrender in the face of such deadly weapons was not dishonourable. A formal statement of surrender was issued and VJ (Victory over Japan) Day was announced on 15 August.

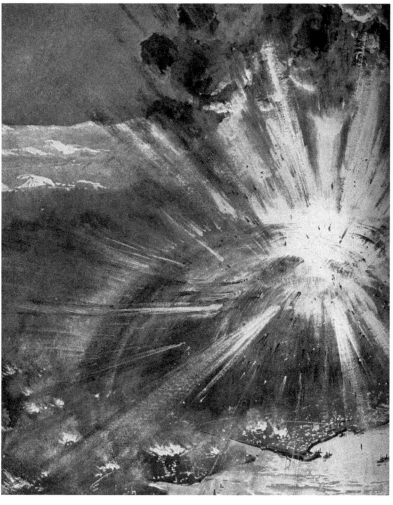

An artist's impression of the atom bomb that was dropped on Hiroshima, 6 August 1945.

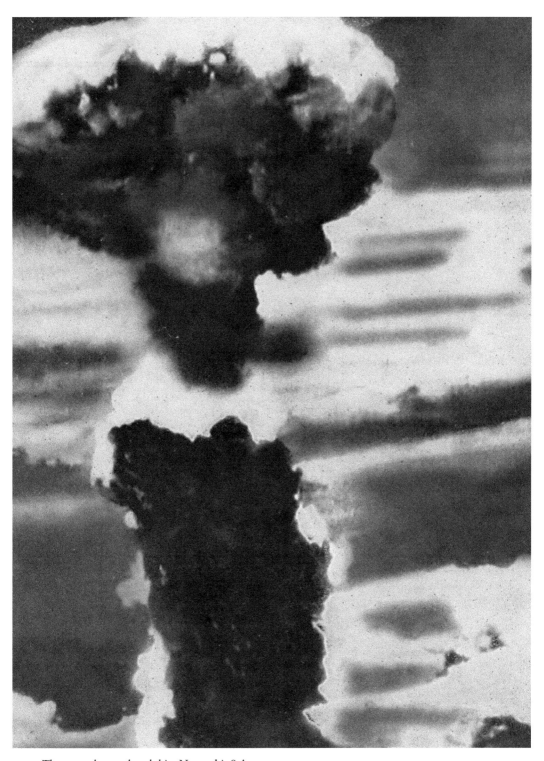

The second atom bomb hits Nagasaki, 9 August.

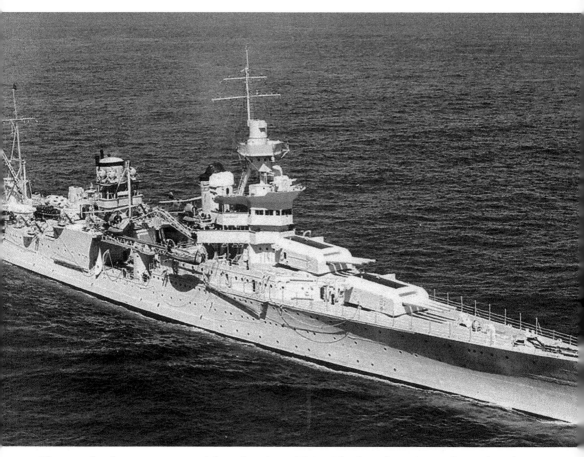

The atom bombs were transported from America to Tinian Island on the cruiser *Indianapolis*. After delivering her cargo at the end of July, the *Indianapolis* was despatched to Leyte Gulf. Her mission still top secret, she never made it, as she was torpedoed by the submarine *I-58*. 900 men went into the water as the ship sank quickly. It was five days before help reached them and by then shark attacks had reduced the number of survivors to just 317.

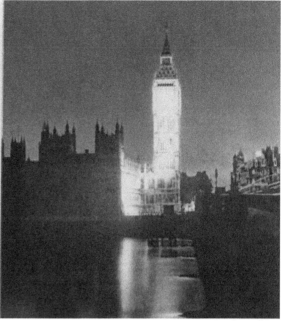

With peace came a relaxation of wartime restrictions. In particular, the lights went on again in cities like London, much to the joy and relief of the British people.

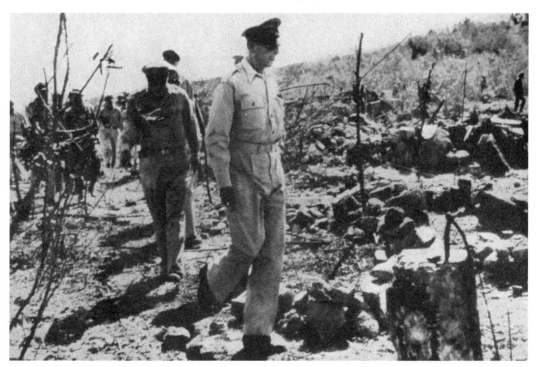

He said he would return! General MacArthur surveys the ruins of the house where he lived on Corregidor.

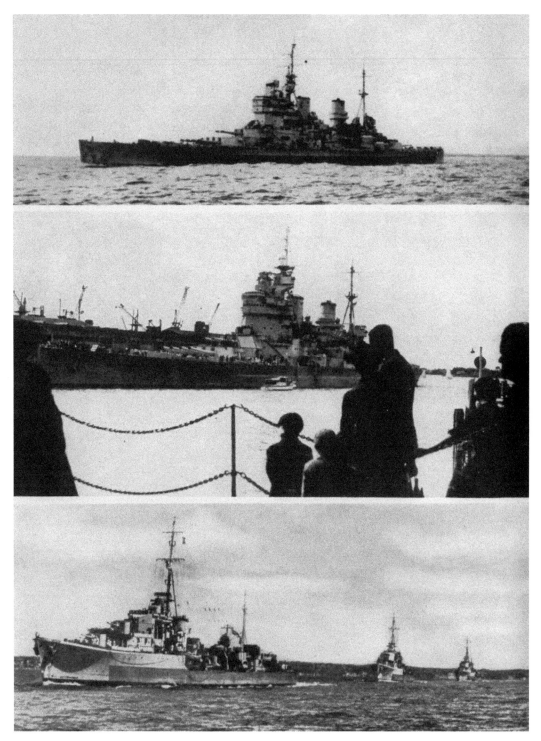

A composite view of just some of the British ships serving in the Pacific at the end of the war: among them are the battleships *King George V* and *Howe*.

September

An artist's impression of the USS *Missouri*. The formal surrender of all Japanese forces took place on her deck on 2 September 1945, six years and one day after the war began.

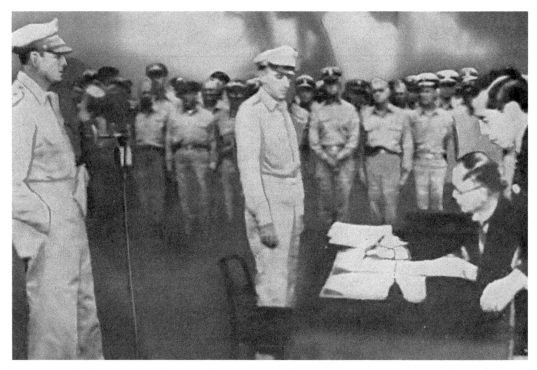

General MacArthur watches as Japanese foreign minister Shigemitsu signs the instrument of surrender.

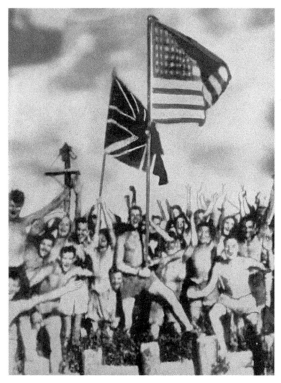

With peace came liberation for the thousands of British and American prisoners of war. Many of them had been badly treated, particularly by the Japanese.

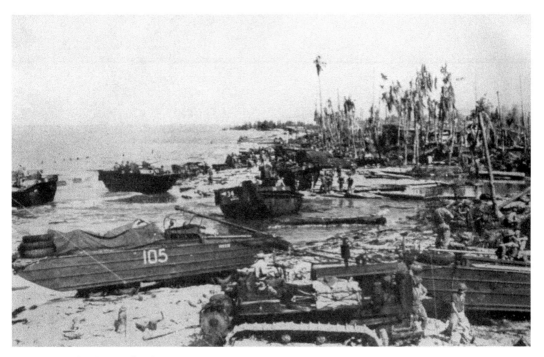

British landing craft ashore in Borneo.

A distant 'stone frigate'. This shows HMS *Atlantic Isle*, a meteorological station on the lonely island of Tristan da Cuna.

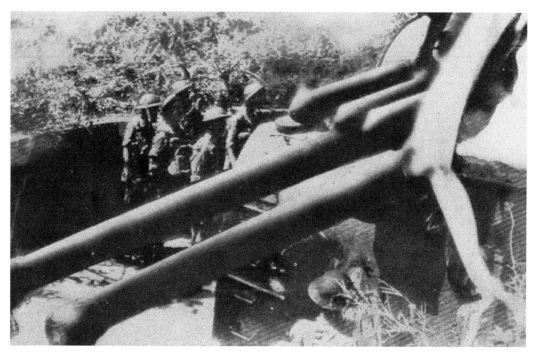

Guns that never fired! September 1945 – British forces take over the forts and gun positions guarding the entrance to Tokyo Bay.

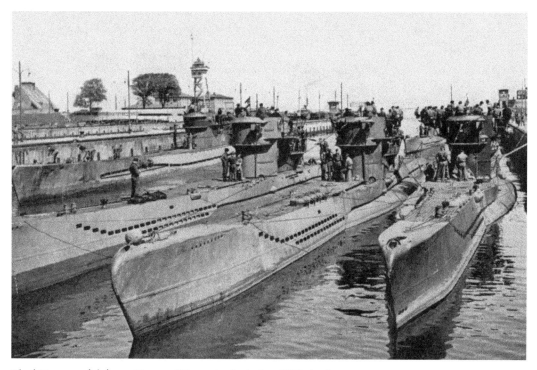

The bitterness of defeat – German U-boats in the lock at Wilhelmshaven.

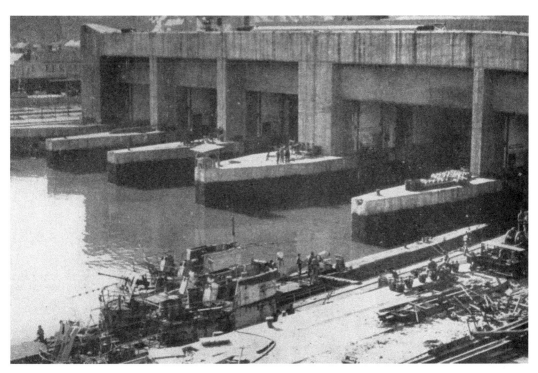

Bombproof German submarine pens, captured and now harmless, at Trondheim in Norway.

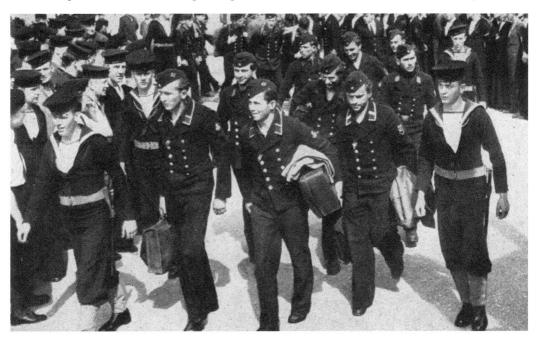

A German E-boat crew going into captivity at Portsmouth. For some of the sailors who surrendered in 1945, the need to rebuild the shattered cities of Germany meant that it would be several years before they saw their homeland once again.

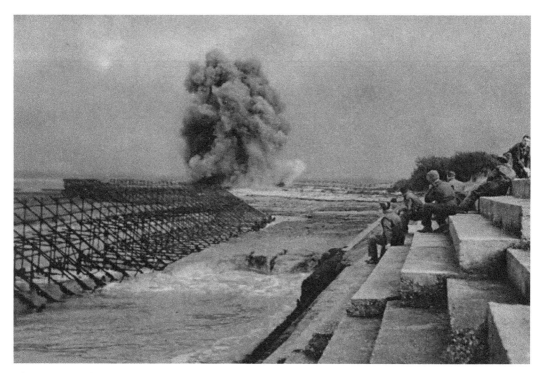

Clearing mines from British beaches, a dangerous but vital task for the Royal Engineers in 1945/6.

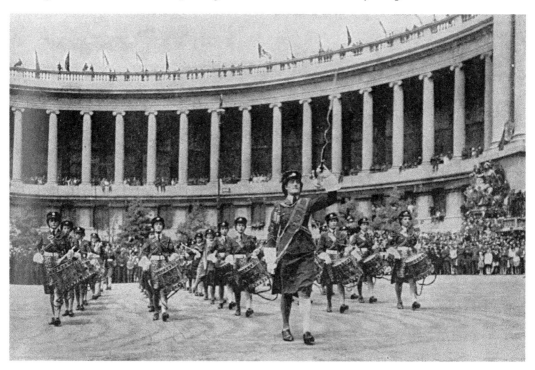

The US cruiser *Augusta*, escorted by British destroyers.

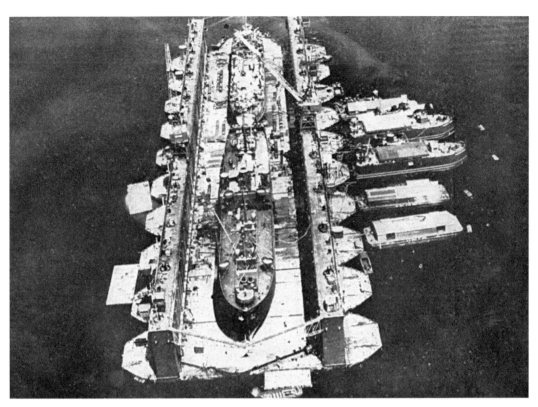

New technology. Advanced base sectional docks could be towed to combat areas and used to disembark troops.

Victory assured, it was time to enjoy the luxury of peace – Australian sailors parade through London before heading back home.

Post-War

Demobilisation of wartime volunteers worked on the principle of first in, first out. A medical, a small cash pay off and a new suit was the best men could hope for. With any luck, their pre-war employers would have kept open their jobs.

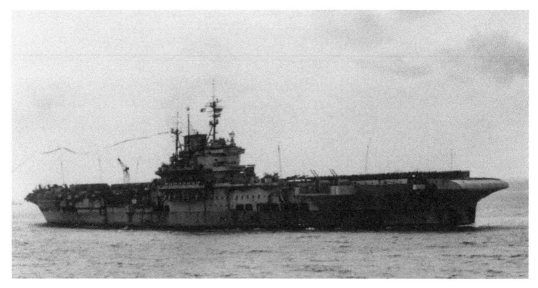

HMS *Victorious* paying off, November 1945.

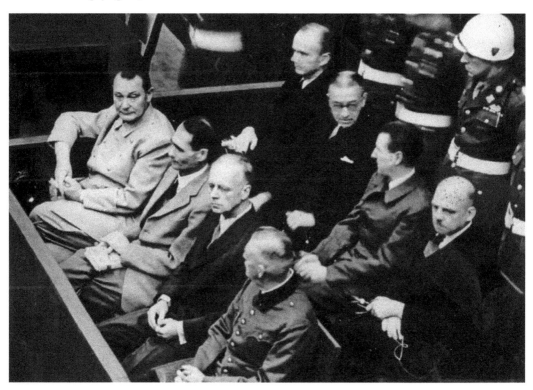

Retribution for Nazi crimes came at the Nuremberg war crimes trials. Hitler was already dead but Goring, Hess, Ribbentrop and others were soon on trial for their lives. Eleven high-ranking Nazis were given the death sentence, although Goring cheated the hangman by taking poison the night before his execution. In this photograph the two naval officers indicted, Donitz and Raeder, sit in the second row behind Herman Goring and Hess.

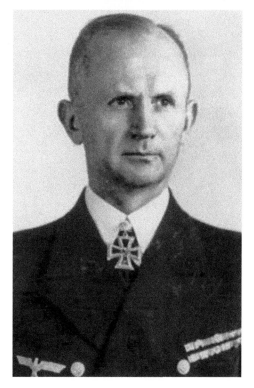

Grand Admiral Raeder was a captive of the
Russians when the war ended and was presented
at the war crimes trials, people felt, because
the Russians held no other high-ranking Nazis.
Even so, he was found guilty of conspiring to
wage aggressive war and was sentenced to life
imprisonment.

Karl Donitz was not found guilty of waging
unrestricted submarine war, as many suspected
might happen, mainly because the Americans had
done the same in the Pacific. However, he was
convicted of issuing the *Laconia* Order, compelling
German sailors to offer no help to Allied sailors
who were adrift in lifeboats, and was sentenced to
ten years' imprisonment.

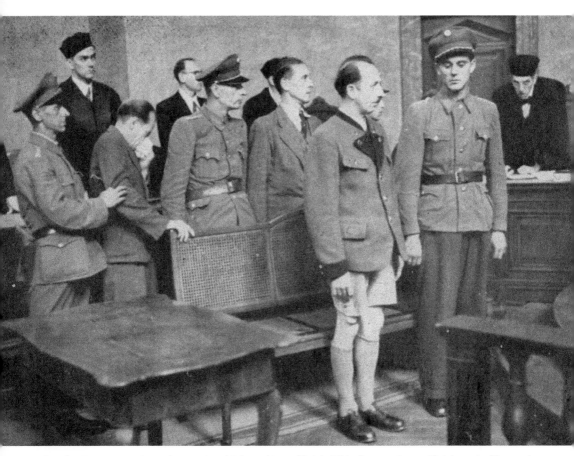

Retribution was not just taken against high-ranking officials. This shows minor officials and officers of the Nazi regime being sentenced for their crimes.

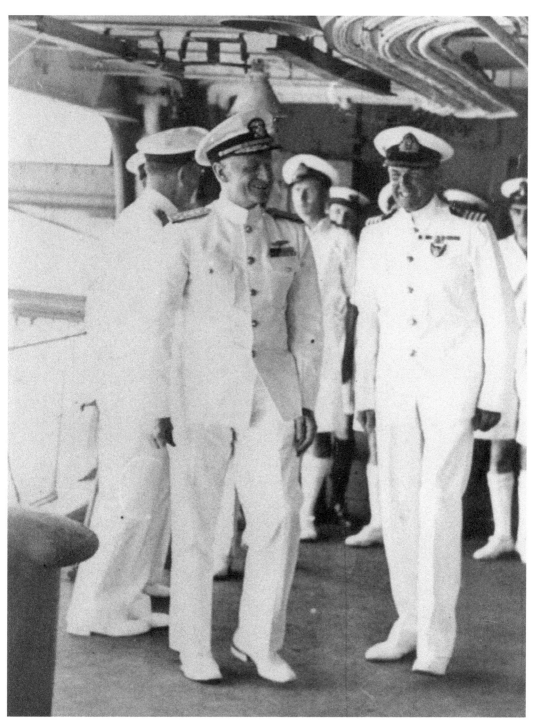

American Admiral Chester Nimitz, who acknowledged that the Americans in the Pacific employed unrestricted submarine warfare against the Japanese. His statement undoubtedly saved the life of Admiral Karl Donitz.

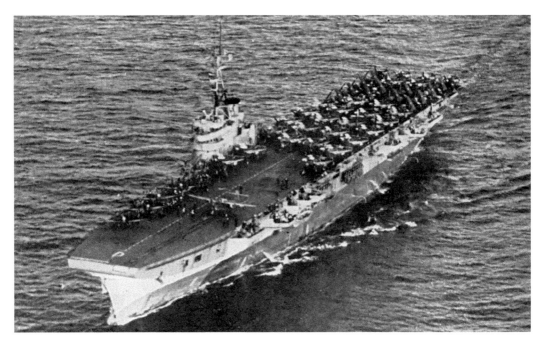

A new fast, light aircraft carrier for the navy.

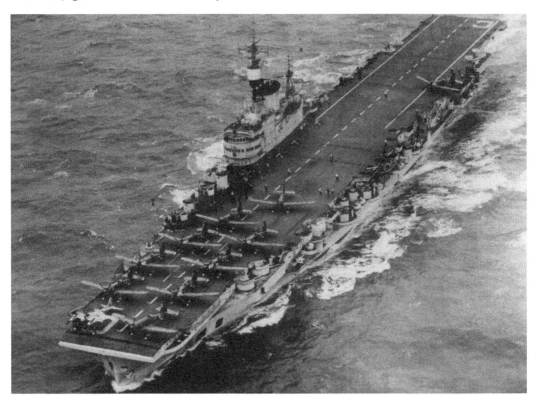

Hornets and Firebrands on the deck of HMS *Victorious*, North Atlantic, 1949.

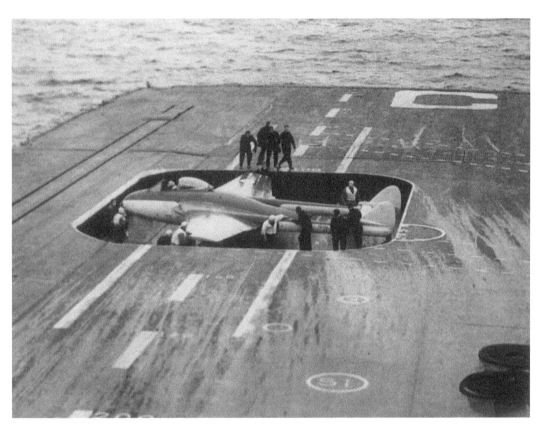

Jet aircraft began to replace propeller-driven planes in the years immediately after the war ended. This shows a Vampire jet going down the forward lift on HMS *Victorious* – a far cry from the days of the old Swordfish torpedo bombers.

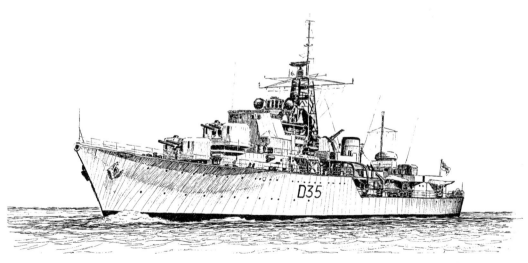

A pen-and-ink drawing of HMS *Diamond* by marine artist John Morris. The *Diamond* was a Daring class destroyer, launched in 1950, and typical of the new ships for a new navy.

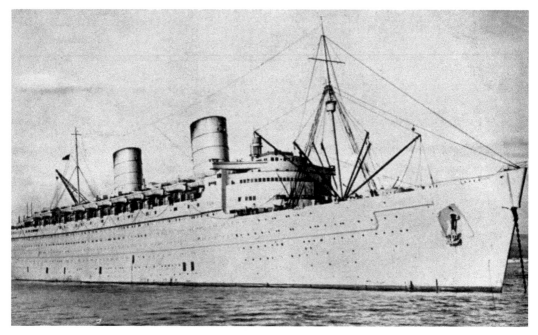

The liner *Queen Elizabeth* taking GIs home from the war in Europe.

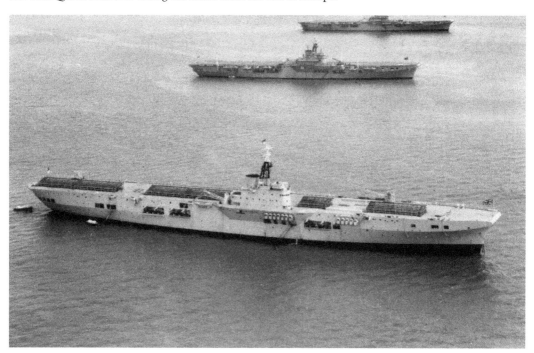

The new navy, with the emphasis on air power at sea. New British aircraft carriers sit in line.

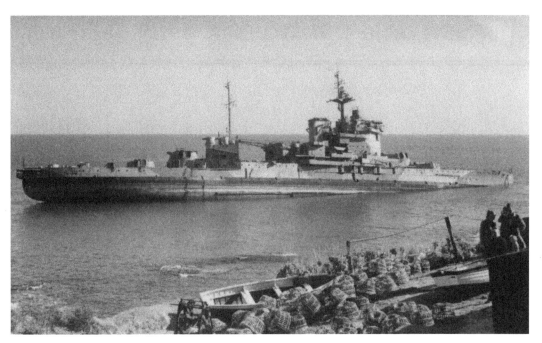

An old veteran of two world wars, which managed to escape the ignominy of the breaker's yard – at least for a while. The battleship *Warspite* foundered on the Cornish coast when she was heading for the scrapyard in 1947.

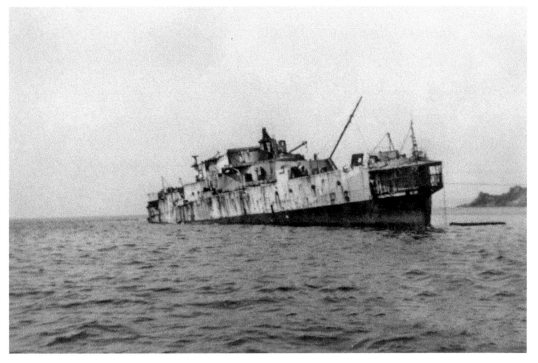

The sad remains of the *Warspite*, broken up where she lay in Prussia Cove.

The last British battleship, HMS *Vanguard*. Even she was not immune to changing policy and the vagaries of naval warfare. She was scrapped in 1960 after less than fifteen years' service.

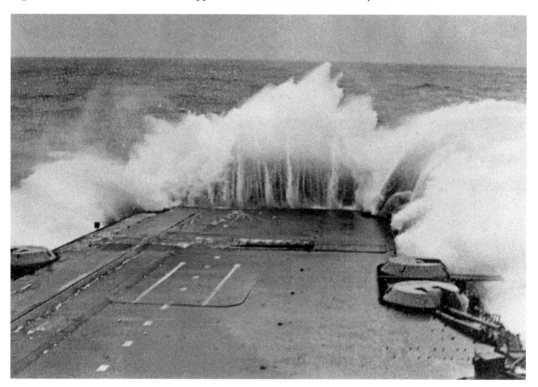

No matter how much the ships of the Royal Navy might change, one thing remained constant – the sea. Here an aircraft carrier smashes her way through heavy sea.

It was clear, almost from the start of their term in office, that the new Labour government had acquired something of a poisoned chalice when it took over from the Conservatives. Waging war was an expensive business. After six long years of conflict, where no quarter was asked or given, Britain was virtually bankrupt and when, almost before the dust had settled on the peace treaties, America suspended her 'lend lease' payments to her ally, it was clear that drastic steps would have to be taken.

As far as the navy was concerned, the economic situation, allied to the inevitable decline of empire, meant a huge reduction in the number of ships available. Within a few years, virtually all of the pre-war vessels that made up a significant part of the Royal Navy had been scrapped, and manpower was severely reduced. The two things went together and, as many of the sailors who were discharged were wartime ratings, the reduction of naval strength was not immediately apparent.

The USA had, during the war years, built themselves the largest navy in the world – taking that mantle from the Royal Navy – and Britain appeared quite content to allow America to carry out the policing that, pre-war, had been a predominantly British problem. And yet the British could never quite abandon their role as champion of lost causes, with successive governments all attempting to retain the power and prestige of the pre-war days – but without the money, machinery or manpower to achieve significant results. In the end, it took the advent of the Cold War and the threat from Soviet Russia to force Britain to revise her policy of reduction of the armed forces.

Already instrumental in the formation of the United Nations, where she was one of five nations given the veto, in 1959 Britain became a significant player in NATO, the mutual defence organisation set up to prevent major conflicts. British ships and troops duly fought alongside the Americans in the Korean War, which broke out in 1950, and carried out their own unsuccessful but bitter campaigns, such as the Suez Operation.

Britain was also committed to fighting a rear-guard action in defence of her dying empire in places such as Malaya and Kenya. In order to fulfil her obligations, the country needed new and powerful weapons for use on both land and sea. By the early 1950s the Admiralty had ordered and built several new light aircraft carriers, two Tiger class cruisers and a number of new smaller vessels, although purists would say that the revolutionary Daring class destroyers looked nothing like any ship they had ever known.

National Service – although the number of men who spent their two years of compulsory service in the navy was nowhere near as many as in the army and air force – added new recruits. Once again, British ships were deployed around the world. The navy had found a new role for itself as part of NATO.